INSTANT LVE

How to Make Magic and Memories with Polaroids

Jenifer Altman Susannah Conway Amanda Gilligan

CHRONICLE BOOKS
SAN FRANCISCO

Library of Congress Cataloging-in-Publication
Data available.

ISBN: 978-0-8118-7926-2

Manufactured in China.

Design by Brooke Johnson

10 9 8 7 6 5 4 3 2 1

Chronicle Books LLC
680 Second Street
San Francisco, CA 94107
www.chroniclebooks.com

We dedicate this book of secrets to you.

In the words of Dr. Land himself,
"One of the best ways to keep a secret is to shout it."

ACKNOWLEDGMENTS

Thanks to Bridget and Matt at Chronicle for their guidance, wisdom, and patience.

Thanks to Brooke for the design.

Thanks to Amy for the gorgeous color-wheel watercolor illustration.

Thanks to our contributors, Mia, Fer, Grant, Matt, Parul, Leah, and Lori, for sharing their amazing creativity.

Thanks to the Impossible Project for keeping the flame alive.

Thanks to Vanessa Mirelez and Kat White for their generosity.

Thank you so much to Ryan Marshall for his work on our book trailer—we are so grateful for your talent and friendship. www.pacingthepanicroom.com

A *huge* thank you to Rabbit! for allowing us to use their song "Camera" in our book trailer. It would not have been the same without—you guys are the *best*. www.saverabbit.com

Thanks to our families and friends for their unending love and support.

Jen would also like to thank her husband, Dennis, who quietly and gracefully put up with her "crazy" while writing this book. And to her daughters—thank you for continuing to seek out snuggles even though she was attached to her computer for the better part of six months and may have once—okay, twice—forgotten to feed you. And to Amy Kay for putting the idea of this book into her head.

Susannah would like to thank her mum for tirelessly cheering from the sidelines, her sister for the use of their single-sister brain cell, and her nephew for being the best thing that ever happened to her.

Amanda would like to thank Sean for supporting her with love, tenderness, and needed hugs. She would also like to thank Alex, Paul, Kelly, and Lesley for their amazing cheerleading from across the sea.

And last, but never least, thanks to Edwin Land for inventing these amazing cameras in the first place.

CONTENTS

page 9

Introduction

page 13

CHAPTER ONE
The Basics

page 55

CHAPTER TWO
The Art of
Composition

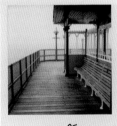

page 95

CHAPTER THREE
Capturing
the Light

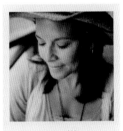

page 111

CHAPTER FOUR
Storage, Display,
and Projects

page 149

CHAPTER FIVE
Inspirational
Portfolios

page 170

Resources

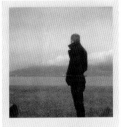

page 175

Index

INTRODUCTION

Polaroids are personal. Artists who shoot them do so for very personal reasons, and the journey that brings each of us to this unique medium is a tale of love, patience, and magic. Yes, *magic*. Everyone has a Polaroid story—do you remember the day you saw your first Polaroid image? There's incredible nostalgia woven through those little glossy squares, like memories imprinted with washes of light. For more than sixty years, Polaroid has been a fixture at family gatherings and fashion shoots and in the wider photography world too, the iconic design of both the prints and the cameras an enduring slice of popular culture. And even when we feared Polaroid was dead, the instant-film community banded together, doing all it could to "save Polaroid," making the art form seem more popular than ever.

The three of us cemented our love affair with Polaroid when our SX-70 cameras came into our lives, and we cherish them today as if they were our children, still dazzled by the images that are conjured before our eyes. The camera's *click and whirr* is the music we dance to as we continue along this path of instant exploration—the realization that we have thirty-five instant cameras between us is testimony to our unending love for the medium. Instant photography made each of us the photographer she is today, and we've learned more about light than any person could have ever taught us. Taking photographs is a natural high, and shooting Polaroids is the highest

high of all. With every image we shoot, we improve on the last, and we've learned never to take our artistic eyes for granted, always to be looking for new ways to capture light or color or feeling. Shooting with vintage cameras requires you get to know the quirks of your equipment; we don't have the guarantee of digital clarity with our instant cameras, but that's one of the reasons we love them so much. Each print is utterly unique, and we've learned to see life in squares.

The way we shoot instant images—slowing down, steadying our breathing, carefully considering every detail—could be a metaphor for life, a way to live mindfully in the moment and not allow ourselves to get too caught up in the past or the future. Sometimes it works, sometimes it doesn't, but it's a continual practice, just like photography.

It is our hope that you'll fall in love with instant photography as we have done, because there is truly no greater feeling than walking through a new city with an SX-70 in your hands and a film stash in your bag. Throughout the book we will use *Polaroid* and *instant film* interchangeably, because even though the company no longer manufactures instant film, it made the cameras we love, and for that reason we are forever grateful to Polaroid.

Just a few years ago the survival of Polaroid film was in question. It was love and patience that saw us through that uncertain time, and it's those same emotions that now give us hope for the future of this film format. We are excited about the new era of instant photography being made possible through the work of the Impossible Project and believe that the future of instant imaging is truly bright. Throughout this book, we'll share our personal experiences with you—our best secrets for capturing the light, some of our favorite ways to display our images, and, of course, our favorite photographs.

In "The Basics" we detail the cameras, film, and accessories available on the market today, describing the technical capabilities of each camera and explaining how to best utilize the

film and accessories. Beautiful, light-infused photographs illustrate the most commonly used cameras, with notes describing how each camera works.

In "The Art of Composition" we explain the building blocks of composition, so that whether you're photographing vintage bottles, a postmodern building, or taking someone's portrait, you'll be able to confidently create a memorable image. We also introduce our first guest contributor, Grant Hamilton, who takes us through his process of shooting colorful abstract Polaroids.

In "Capturing the Light" we explore how light affects instant film, including advice for successful shooting in any lighting situation, and a series of unusual lighting setups for you to try yourself.

In "Storage, Display, and Projects" we show you how to care for your instant prints, share our best storage solutions, and provide ideas and imagery to inspire your instant displays. This chapter also features special projects from our other fabulous guest contributors: Lori Andrews, Parul Arora, Fernanda Montoro, Mia Moreno, Leah Reich, and Matt Schwartz.

The "Inspirational Portfolios" in the latter part of the book showcase exactly how versatile, innovative, and jaw-droppingly brilliant instant photography really is.

And finally, the "Resources" chapter features our personal selection of shops, products, books, and artists, all of whom love instant photography as much as we do.

Are you ready to explore?

With (instant) love ~
Jen, Susannah, and Amanda

Chapter One

THE
BASICS

There is an instant camera out there for everyone. As you make your way into the world of instant photography, you'll undoubtedly come across cameras we don't mention here, most of which you won't find film for either. Each of us has many cameras in our collection we can't use but keep because they're just so beautiful. Life as a Polaroid photographer isn't only about the images: we're in love with the cameras too.

In this chapter we'll profile specific Polaroid and Fuji Instant camera models, including a short history of each camera, the type of film used, how to load and unload film, and the most appropriate lighting situations to seek out. We'll also review the various film types and Polaroid camera accessories still out there and investigate the image manipulations possible with different cameras. But first, let's start with the man behind the genius of instant imagery: Dr. Edwin Land.

American-born Land was a master inventor and scientist who consistently challenged the boundaries of photographic technology during his years at Polaroid, the company he founded in 1937. In true mythological style, it's said that Land was inspired to create instant film after his three-year-old daughter asked why she couldn't see photographs from their camera straightaway; it was a question that led to photographic history being changed forever when Polaroid released the Land Model 95 in 1948, the very first instant camera.

Hugely popular with amateurs and professionals alike, the next generation of instant camera to shake the market was the SX-70, the first instant SLR camera, launched in 1972. Between 1948 and 2005, Polaroid released hundreds of instant camera models, including branded cameras for Mattel's Barbie doll and the ubiquitous Hello Kitty, but as Polaroid increasingly set its sights on the digital revolution in photography, the production of instant film ceased in 2008. The distress among the Polaroid photography community was profound.

Within months of Polaroid's announcement, two instant-film photographers who refused to let the medium die founded the Impossible Project. In October 2008, Dr. Florian Kaps and André Bosman purchased the last functioning Polaroid film production facility, in Enschede, the Netherlands. As the original Polaroid color dyes were no longer available, the team had to reinvent the technology from the ground up, spending months of research and development creating new integral film for use in the original Polaroid cameras. Their first line of film was launched worldwide in April 2010, and the company has since created an extensive catalog of color and black-and-white films for 600, SX-70, and Spectra camera formats. Essentially saving the medium from extinction, the Impossible Project has introduced a whole new generation of photographers to the joys of instant-film photography.

For the first-time shooter, deciding which camera to use is daunting, as there are so many different models out there, but whether you are using expired Polaroid film or the latest Impossible Project film, you'll probably be shooting it in a Polaroid model camera. Polaroid produced countless variations of its cameras over the years, so we'll focus on the cameras most commonly used by enthusiasts today; cameras within a particular series usually used the same film type and had only minor differences in structure and functionality. We'll be looking at the original Polaroid Land Model 95 and Pathfinder cameras, the peel-apart film cameras, the

very popular SX-70 series, the 600 series cameras, the SLR 680/90, the Spectra, and the Fuji Instax (made by Fujifilm, not Polaroid). For further information on less commonly used models, please check our Resources chapter. Additionally, if you need further instruction on any of the models we discuss, they are readily available online, and are very often free to download.

A note on film: We'll be using two key terms when referring to film in this book, *integral* and *peel-apart*. Integral film is the easily recognizable film square with the white frame that shoots out the front of the camera (or in the case of instant Fuji cameras, the top of the camera); it's the most commonly shot instant film used in both modern Polaroid and instant Fuji cameras. Peel-apart film (also referred to as *pack film*) is manually pulled out of the camera once the image has been exposed. When the development time has elapsed, the film's paper backing is peeled away from the image and the print is left to dry.

THE CAMERAS

Polaroid Land Model 95 and 110A and 110B Pathfinder

Years of Release: 1948–early 1960s

HISTORY

The Polaroid Land Model 95 was the first Polaroid camera ever released. The Polaroid Land Model, the Pathfinder, and various other cameras released between 1948 and the early 1960s all used "roll film." While this film is no longer produced, you may get lucky and find some on eBay—but bear in mind that it will be long expired. However, you may also come across modified Land

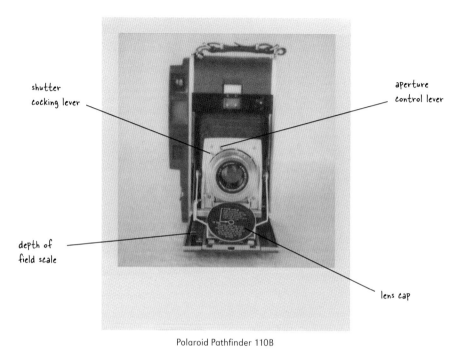

shutter
cocking lever

aperture
control lever

depth of
field scale

lens cap

Polaroid Pathfinder 110B

Models and Pathfinders, vintage cameras converted to use peel-apart film. Any number of camera shops will perform this conversion (check out the Resources chapter for more details). The most popular conversion model is the 110B Pathfinder, because it's equipped with one of the best lenses Polaroid ever used: the 127mm, f/4.7, four-element Yashinon.

FILM

Original Polaroid roll film. Converted cameras use Fuji FP 100C, Fuji FP 100B, Fuji FP 3000B peel-apart film, Polaroid 100 series peel-apart film, and Fuji 4- x 5-inch sheet film (depending on the size of back).

BATTERY
No roll film cameras require batteries.

BEST LIGHTING SITUATION
Because the Pathfinder is equipped with aperture and shutter speed controls, you can use the camera in nearly all lighting situations. Use an external light meter to help read the light. Additionally, the models are equipped with a PC socket for flash sync using a bulb or electronic flash.

FUNCTIONS AND CAMERA USE
The Pathfinder model was considered a professional-level camera at the time of its release. Its small, but high-quality lens and manual controls allowed more freedom than most other instant-film models and resulted in nearly medium-format–quality images. Because it's fully manual, you need to be familiar with the basics of photography, including how to determine f-stop and shutter speed (see the Resources chapter for our favorite books on photography basics).

Opening To open the Pathfinder, simply undo the small latch at the front of the camera, push the cover down until the support arms fasten firmly, and pull on the metal slide underneath the lens to slide it forward until you feel it lock into place. Be sure to also open the attached lens cap. You can still see through the camera when the lens is covered, owing to the placement of the viewfinder, and failing to open the lens cap will result in a blank image.

Loading the Film Please refer to the Loading the Film section under the next grouping of cameras, the Polaroid Automatic Land Cameras.

Adjusting the Settings The Pathfinder is fully manual. First, determine your light reading with an external meter. To make the appropriate

adjustments, move the lever with the red arrow to set the f-stop. Set your shutter speed by aligning the red mark on the large, ridged, silver dial around the lens to the number that corresponds to your light reading. There's also a depth of field scale just to the right of the lens. The guide is used with close-up filters, often sold with the camera if the unit is still in its original leather box. Close-up filters allow you to get physically closer to your subject and are usually packaged in a small leather case that includes a measuring tape; the measuring tape details the exact distance needed between the camera and your subject in order to achieve the proper depth of field. The tape notes your depth of field as a number—these are the numbers found to the right of the lens. Once the close-up filter is attached, you will find that your subject is not in focus through the viewfinder. However, as long as you have set the focus knob to the corresponding depth of field mark (noted by that important measuring tape), your final image will be focused. Be sure to also note the placement of the viewfinder in relation to the lens, as they are not aligned. This takes some guesswork on your part, as what you observe through the viewfinder is not exactly what the lens is seeing. This is especially critical when using the close-up filters, as the camera is in much closer physical proximity to your subject. Just be sure that you have aligned your subject with the lens and not the viewfinder.

Taking the Picture Composition and focusing take place in the viewing window, where you'll see four lines for framing and a triangle for focusing. Place the triangle over the most central part of your subject, moving the focusing knob until the double image within the triangle merges into a single, focused image. Make sure that your composition is framed within the four parallel lines, as these determine what will be included in your Polaroid print. Above the lens is

What we love: "One of the things I love most about the Pathfinder is its age—it truly feels like a piece of history when you hold it. The fact that it's fully manual is a wonderful challenge that pushes me to be a better, and more patient, photographer. And the image quality is breathtaking." —Jen

a small silver lever that must be cocked to the right before the shutter button is pressed. Hold the camera to your eye and press the shutter button (the silver bar on the right side of the lens), keeping your fingers and the camera as still as you can.

Developing the Print Again, please refer to the steps under the next grouping of cameras, the Polaroid Automatic Land Cameras.

Polaroid Automatic Land Cameras

Years of Release: 1963–1974

HISTORY

The distinctive-looking folding Polaroid Automatic Land Camera Series (100 to 400 series) were all very similar in design and function. They were first produced in the early 1960s, and Polaroid continued to refine and develop its Automatic cameras until the mid-1970s. All (save for a few professional-level models) have automatic exposure and folding bellows and take 100 ISO speed peel-apart film, but unlike the earlier Polaroid cameras that used roll film, the film developed outside the camera after exposure. Automatic Land cameras weren't the prettiest Polaroid cameras ever made, but they certainly represent an era of impressive advancement in Polaroid's history.

FILM

Polaroid 100 series peel-apart film and Fuji FP-100C, Fuji FP-100B, and Fuji FP-3000B.

BATTERY

Batteries can be an issue for these cameras. While you can still find compatible batteries online, most users choose to modify their cameras to take AAA batteries. If your camera is not converted, you may need to do some battery research depending on your camera's make. Check the Resources chapter for further information and sources. (Please note that the professional-level models, the 180, 185, 190, and 195, do not require batteries unless utilizing the flash.)

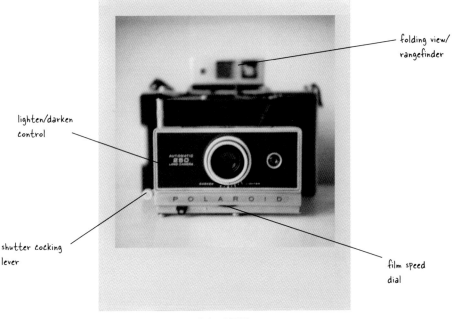

folding view/
rangefinder

lighten/darken
control

shutter cocking
lever

film speed
dial

Polaroid 250

BEST LIGHTING SITUATION

These cameras are best suited to outdoor light. Bright sunshine produces good results for color, while cloud cover on a sunny day can result in beautifully subtle images. Paired with an external flash, it can also be used to shoot successfully in low-light conditions.

FUNCTIONS AND CAMERA USE

The 100 to 400 series cameras were known as folding cameras, as they were built with bellows that fold in and out when opening and closing the camera. These models are all automatic and use Polaroid's "1, 2, 3 System," walking the photographer through the photo-taking process step by step. The main functions on the camera are indicated

with numbers 1, 2, and 3, and if you follow those, you shouldn't have any problems. The hardest part of using these cameras is timing the exposure of each instant print—a stopwatch and some patient trial and error are required. However, one of the advantages of Fuji peel-apart film is that unlike its late Polaroid counterpart, Fuji film stops developing on its own. Just ensure that you have given the image adequate time to develop before you peel.

Opening The Automatic Land Camera does not resemble a camera when closed, as it's hidden inside a plastic cover, so lift the top edge of the cover to reveal the camera inside. The cover can be removed by pushing on the metal clip that holds it in place. The rectangular piece above the camera is called the *folding view*: flip it up and it will attach itself to a magnet. Push the metal arm numbered 1 up slightly, and pull the front part of the camera out as far as it will go—you will see the bellows open up and the support arm click into place.

Loading the Film All Automatic Land Cameras take peel-apart film loaded into the back of the camera. The film pack is rectangular in shape and larger than integral film; you will notice some white paper tabs attached to the film pack. To insert the film, slide the latch on the bottom side of the camera to open the back door. With the white tabs facing out, slide the film pack (window-side down) into the camera until it feels firm and in place—the white tabs need to be flat. Close the back door with the larger black tab sticking out of the small opening in the side of the camera; pull on the black tab to release the film cover from the camera—don't be shy about putting some muscle into it! First-time users often fear hurting their Land cameras, but you can pull with confidence. Once the film cover is all the way out, the white tabs should now appear through the small opening in the side of the camera—leave them where they are for now.

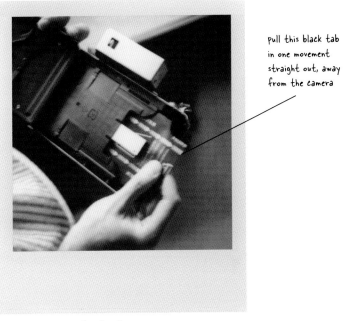

pull this black tab in one movement straight out, away from the camera

Loading the camera

Adjusting the Settings Most models offer two film speed settings (75 and 3000), which are set using the dial that sits at the bottom of the front of the camera. Before taking your shots, you must set the dial to the correct speed for your film. For example, if you are using Polaroid 100 Blue film (100 speed film), you will set your camera to 75 (the closest) and if you are using Fuji's FP 3000B (3000 speed film), you will set your camera to 3000. Note: Some of the more expensive models feature additional speed settings.

Taking the Picture The button marked 3 must always be in the down position before shooting.

1. Focus. The Automatic Land Camera uses a focusing system that is quite different from other, more modern Polaroid cameras. There are three different types of viewfinders used for composing and focusing, and many Land cameras have two holes in the viewfinder. The rangefinder focusing system requires the photographer to look through a small viewing window (known as the *folding view/rangefinder*) where a double image appears. You may have this hole marked as *Focus* on your camera. To focus your shot, look through the window while sliding the number 1 buttons (one on each side of the camera), moving them back and forth until the subject becomes a single image.

 Next, look through the *View* window and compose your scene. First-time users are often unaware of this system and are confused about why their pictures are blurry. Focus first, and then compose.

 Some of the lower-end models came with a viewfinder that includes horizontal lines that you move up and down between the subject's forehead and chin when shooting portraits. They also have a scale so the photographer can estimate the distance between the camera and subject. Some of the higher-end models came with one viewing window to both focus and compose the image—a rectangle to compose the scene and a bright spot in the center to focus.

2. Shoot. Press the shutter button, marked number 2, to take the picture. Be sure to hold your finger and camera steady as you press the button.

3. Cock the shutter, marked 3, back into the down position. Always remember to do this after taking each picture.

Unloading the Film and Developing the Print Here comes the tricky part. The art of pulling the print from the camera and judging development time takes practice. It requires a little bit more work than integral film, but it really allows you to play a greater part in the picture-taking process.

Hold the camera in your left hand and pull the small white tab out of the camera. Once again, don't be shy. As you pull, a little door will open (don't panic, it's supposed to open) and another larger black tab will appear. This is the film.

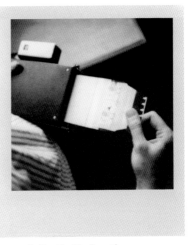

You will still be holding the camera in your left hand. With your right hand, pull the larger tab in the middle all the way out of the camera with strength and do not stop. You now have your peel-apart shot. As soon

Pulling the film from the camera

as you start to pull the larger tab, the developing process begins and you need to start timing. Hold it in your hand by the tab or lay it down flat.

The film box usually indicates development time for the film; depending on the film and the ambient temperature, development time can be anywhere from 15 seconds to 4 minutes. Fuji also lists product specifications on the film tab itself. Some cameras come with a timer—you could also use a stopwatch. Once the developing time is up, carefully peel the white print from the backing sheet, starting at the corner and being careful not to get any chemicals on your skin. Your print will still be wet, so let it dry; the backing sheet can now be discarded.

Note: The 100, 250, 350, and 450 are known to be superior in quality to other models as they have metal casings (the consumer models are plastic), three-element glass lenses, and stronger construction overall.

What we love: "I love that working with these cameras and film is like stepping back to a time when taking photographs was seen to be an art and not something you just snap on your phone. Although the images are instant, using these cameras takes patience and you will need to dedicate an afternoon or two to learning their quirks." — *Amanda*

Polaroid SX-70 Original Model

Years of Release: 1972–early 1980s

HISTORY

The Polaroid SX-70 was the first instant SLR (single-lens reflex) camera and is still considered to be one of Polaroid's greatest technological achievements, much loved and sought after by camera enthusiasts today. The first instant camera to use integral film, the camera was powered by a battery contained within the film pack. The most widely recognized SX-70 has a chrome finish with tan

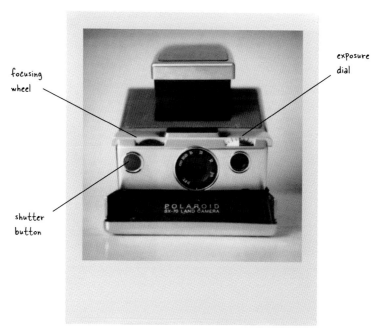

focusing wheel

exposure dial

shutter button

Polaroid SX-70

leather inserts on the upper and lower surfaces of the camera body, and folds down flat into a conveniently portable size. Polaroid later released a less expensive line of SX-70s including the Model 2 camera with its white plastic body and dark brown imitation leather inserts, and the Model 3 (black plastic, dark brown inserts), which is not an SLR and so does not feature manual focus (identified by the "see-through" viewfinder on the front of the camera).

The SX-70 ushered in a whole new era of Polaroid photography, embraced by both photographers and artists, including Robert Mapplethorpe, Andy Warhol, Walker Evans, and André Kertész.

The most popular SX-70 models released include: SX-70 Land Camera, SX-70 Model 2, SX-70 Model 3, SX-70 Alpha 1, SX-70 Sonar OneStep, and Time Zero OneStep.

FILM
SX-70 cameras were designed to use integral film at 100 ISO. PX 70 Color Shade, PX 100 Silver Shade UV+, SX70 Fade to Black (all Impossible Project films), Polaroid Artistic TZ, Polaroid Time Zero (original film made for SX-70 cameras), Polaroid 600/779 film (with manipulations that are explained later in this chapter).

BATTERY
These cameras do not require separate batteries, as a disposable battery is contained within the integral film pack.

BEST LIGHTING SITUATION
You will need a great deal of light when using the SX-70 indoors, as without adequate lighting, your indoor shots may result in blurred images. If you are shooting in a room that does not have a lot of light, move your subject near a window and use a tripod. The SX-70 tripod accessory (accessory number 111) allows you to mount your camera to a tripod. These can still be found on eBay.

Light cloud cover on a sunny day yields beautiful results with this camera. As with all Polaroid cameras, full sun will always work, but be careful when shooting different films with the SX-70. Polaroid 600 film, used with camera or film modifications, should be fine in full sun, though shooting in light shade produces the best results, color-wise. The newer films from the Impossible Project can be quite sensitive, and too much light will affect the development process. If you do shoot these films in full sun, take note of the Impossible Project's advice to shoot with a protective shade to shield the film after exposure (visit Impossible Project's Web site for more details).

FUNCTIONS AND CAMERA USE

The world's first folding instant SLR camera was a feat of engineering genius, a slim-line camera that folds down neatly to be carried in a coat pocket or bag. That these 30-plus-year-old cameras still work today is a testament to their beautifully efficient design.

Opening and Cleaning To open the camera, hold it in the palm of your hand and lift the small end of the viewfinder cap up toward you. The camera will pop up from its folded position. There is a metal support arm with an arrow on the side of the camera that you will feel lock into place.

To open the film door, press down on the yellow tab on the right-hand side of the camera and it will drop open. You will see two rollers inside the film door: these need to be clean and should be inspected each time you insert a new film pack. Instant film is made up of layers of chemicals that can sometimes leak as the film exits the camera through the rollers. The rollers can be cleaned with a dry or damp cloth. Using the gear, turn the rollers as you clean— you will find any residue left behind is usually around the edges of the rollers. If you use a damp cloth, ensure that the rollers are completely dry before adding the film and closing the camera.

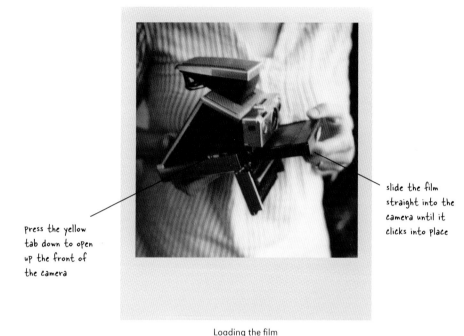

press the yellow
tab down to open
up the front of
the camera

slide the film
straight into the
camera until it
clicks into place

Loading the film

Loading the Film With the small paper tab facing outward, slide your film into the compartment and push it in until the narrow plastic strip across the top of your film pack snaps open. Upon closing the film door, the dark slide/film cover will automatically eject, ready to be discarded. Your camera is now ready to take a photograph.

Taking the Picture Hold the camera in the palm of your left hand, keeping your fingers away from the exit slot at the front—this is where the photograph will eject. Use your right hand to control the focusing wheel and the shutter button. Be aware of where your fingers are at all times. You do not want fingers to stray anywhere near the bellows. The bellows on a vintage camera are fragile and easily

damaged by a misplaced finger jab, so try to keep your fingers away from the front of the camera, the exit slot, and the bellows.

Depending on your light source, you may need to adjust the exposure using the black and white dial on the front of the camera. To lighten your image, turn the dial toward white, to darken, turn the dial toward black. Leaving the exposure dial in the middle is acceptable for many of the newer films. The Impossible Project provides suggestions for using the exposure dial for each of its films on its Web site.

To focus, place the camera to your eye and look through the eyepiece in the viewfinder. You should see a black frame—make

sure you can see all four corners of the frame. With your right index finger, move the focusing wheel back and forth until your image comes into focus.

In the lower section of the frame, you'll see a circle with a line through it: this is the split circle that helps you focus the lens in low-light situations and for close-up shots. To use the split circle, try to find a vertical line within your composition to lay your split circle over. Move the focusing wheel from left to right until the vertical line matches up. For example, if you were to photograph a lamp, you would line up your split circle over the vertical outline of the lamp so that the horizontal line of the split circle crosses over that vertical line/edge. You would then start to move the focusing wheel back and forth until the edge of the lamp is lined up, sharp and in focus. As long as your distance from the subject remains the same, you can then recompose your image while keeping the focus intact.

Once you've focused and composed your shot, you're ready to press the shutter button. Hold the camera still and keep your finger steady as you press the shutter button; do not move your finger or the camera until the photograph has ejected from the exit slot. While the image develops, it's best to hold it at the bottom of the white frame—within a few minutes you'll have your own piece of Polaroid history in your hand.

As you take each picture, you'll notice the counter on the back of the camera counting down. As SX-70 cameras were designed for film packs holding ten instant exposures, the counter will always be set to 10. Some of the newer films have only eight pictures in a film pack, yet when you insert those packs into your camera the counter will still display 10, so keep this in mind when shooting. If you are using the new film, press the shutter two more times after your last shot so the counter resets to 10 when you insert a new pack of film.

Unloading the Film Once you have taken your eight or ten shots and you know the pack is empty, press the yellow tab on the side of your camera again to open the film door. Pull on the small tab at the front of the film cartridge, and your film pack will slide right out.

MANIPULATIONS

Since the original Time Zero film was discontinued, many SX-70 owners have been using Polaroid 600 film in their cameras. This faster film has an ISO setting of 640 and will therefore overexpose, feeding too much light onto your image, resulting in a washed-out photo. However, it's possible to use Polaroid 600 film in an SX-70 camera by making a few simple adjustments to the film and camera.

MATERIALS

Neutral Density film pack filter made specifically for Polaroid SX-70 film packs. You can find the filters on eBay. Search for "Polaroid SX-70 ND filter."

Craft knife or dark slide/piece of thin card, depending on which option you use

Tape

PROCESS

1. The first step, dealing with the four little nubs on the underside of the film pack, can be done in either of two ways:

 Remove them with a craft knife or twist them off with a pair of pliers.

 or

 Use an old dark slide (or any thin card) to guide the film pack into the camera—place the dark slide into the camera while sliding the film pack over the top of it. As you push the film pack toward

the back of the camera, slowly pull out the dark slide and the film should slip into place. If you can do this, you will not need to shave off the four nubs. You will need to add the filter as described in step 2 before inserting the film into the camera.

2. To reduce the amount of light going into the camera for the faster film, place a Neutral Density filter over the top of your film pack. Lay your filter over the top of the film pack and tape it down so that it won't move while inside the camera. Make sure you keep the filter free of dust and scratches, as these will show up on your exposed image.

 Another option is to use a filter that sits over the lens. We don't recommend using this type of filter, however, as it often distorts your view of the subject and makes it harder to focus.

3. Insert the film pack into the camera with the small tab facing out and close the door. The dark slide will automatically eject.

4. Many cameras also need the exposure dial set to darken for correct exposure, even when using the ND filter. All vintage cameras come with their own particular quirks, so trial and error will tell you how your camera works best. You may find that simply adjusting the exposure dial without using the filter will work with your camera.

5. Compose and shoot!

Note: Some photographers choose to convert the camera completely by modifying the photocell, but we don't recommend doing this, as the new films are made specifically for SX-70 cameras and work with the camera in its original form.

OTHER MODELS: THE POLAROID SX-70 ONE STEP AND POLAROID SX-70 SONAR/AUTOFOCUS

The SX-70 One Step was one of Polaroid's most popular models, and with its white, plastic body and instantly recognizable rainbow stripe, the camera looks more like a toy than a piece of photographic equipment. The One Step is a point-and-shoot–style camera and can be used with the Impossible Project's SX-70 films.

Some of the later SX-70 models feature both manual and automatic focusing, using a sonar transducer to power the autofocus and send sound waves to the subject. Holding down the shutter button partway previews the image. Once you're happy with the focus, the button can be fully pressed to expose the shot and eject the photograph. Automatic focus can be switched off by pressing the autofocus override switch located just above the shutter button.

Note: The viewfinders on these cameras do not have the split circle used for focusing.

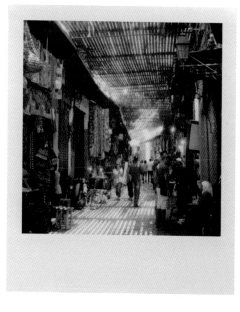

What we love: "My SX-70 has become an extension of my eyes. It's such an important part of how I see the world. It looks fabulously retro, feels good in my hands, and helps me make magic with those little squares of film. The dreamy potential of an SX-70 plus integral film cannot be replicated by digital cameras—it's completely unique." —Susannah

Polaroid 600 Cameras

Years of Release: 1981–early 2000s

HISTORY

The first Polaroid 600 camera and film were released in 1981. The model had many different incarnations beginning in the early 1980s and lasting until Polaroid closed its film factory in 2008. There's a vast range of 600 cameras from the fun One Step 600 to the more professional SLR 680. Marketed as a fun camera to use for taking snapshots, they're probably the best known of all the Polaroid cameras. Their advertising slogan was the simply stated *Polaroid Means Fun*.

FILM

Polaroid 600, Impossible PX 600, PX 600 UV+, PX 600 Silver Shade, and PX 680 Color Shade.

BATTERY

These cameras do not require separate batteries, as a disposable battery is contained in the integral film pack.

BEST LIGHTING SITUATION

These cameras were designed for casual use, hence many of the later models contained a built-in flash, ideal for picture-taking at parties. For the best colors and tones, try shooting outdoors with the flash turned off.

FUNCTIONS AND CAMERA USE

The functions and uses of the 600 camera are the same as the SX-70, it just takes different film.

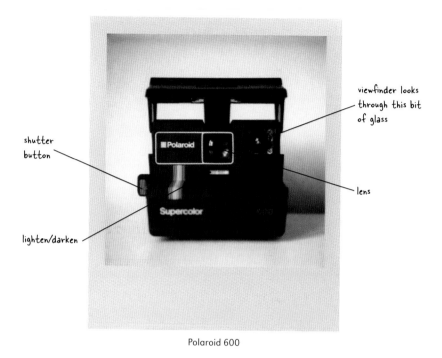

viewfinder looks
through this bit
of glass

shutter
button

lens

lighten/darken

Polaroid 600

Loading the Film Depending on your camera, there will be a button, usually on the side or at the front of the camera, that you press to open the film door. Slide the 600 integral film into the film compartment until you hear it snap into place and then close the film door. The dark slide/film cover will automatically eject.

Adjusting the Settings The earlier models were designed to make picture-taking easy and for that reason had no real settings to adjust. However, later models included more options for photographers to set their exposure with lighten and darken controls and built-in flash units.

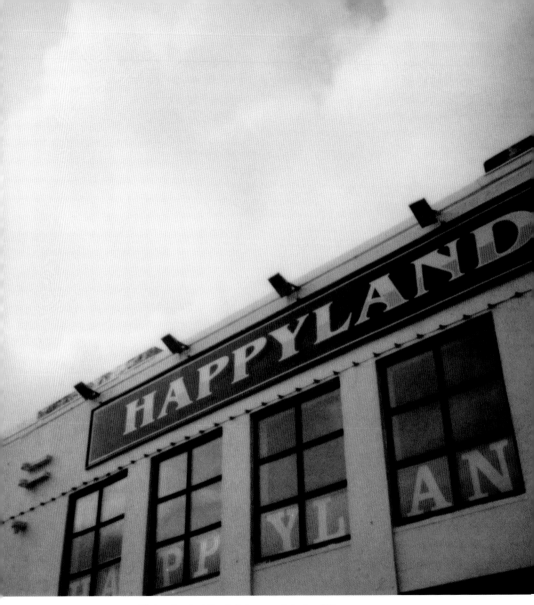

What we love: Just like digital compacts today, 600 cameras are fun and easy to use. While SX-70s and 680s sell for a premium price, 600s are a more affordable way to try instant photography when you're first starting out.

Taking the Picture The fixed focus of the 600 cameras gives you a focus range of roughly 3 feet to infinity, so it's best to stand no closer than 3 feet from your subject. Compose your scene and steadily press the shutter button, holding the camera still until the instant image has ejected. As with the SX-70, it is important to keep your fingers away from the exit slot.

Unloading the Film To empty the film cartridge, simply open the film door and pull on the film tab. The film will slide right out.

Polaroid SLR 680/SLR 690

Years of Release: 1982–1987/1996–2007

HISTORY

The Polaroid SLR 680 was released in 1982, ten years after the SX-70, and while the 600 cameras were aimed at the consumer market, the 680s were touted as the professional's camera. In 1996, the SLR 690 was released; production was discontinued in 2007.

FILM

Polaroid 600, Impossible PX 600, PX 600 UV+, PX 600 Silver Shade, and PX 680 Color Shade.

BATTERY

These cameras do not require separate batteries, as a disposable battery is contained in the integral film pack.

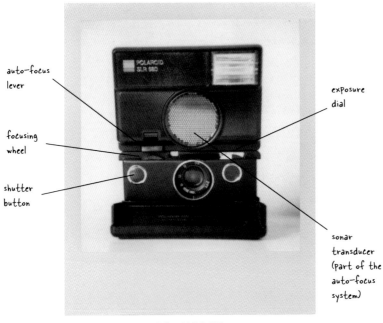

auto-focus
lever

exposure
dial

focusing
wheel

shutter
button

sonar
transducer
(part of the
auto-focus
system)

Polaroid SLR 680

BEST LIGHTING SITUATION

The Polaroid SLR 680 has a fast shutter and works well in low light. It also features a built-in flash designed to be used at all times, but your own photography style will dictate whether you want to use flash for your photographs.

The camera performs well indoors with ample lighting, and we find that the SLR 680 deals with low light better than the SX-70. Like the SX-70 and 600 cameras, the SLR 680 performs well in bright sunlight, as well as shade and light cloud cover.

FUNCTIONS AND CAMERA USE

Because it is a more modern version of the SX-70, you'll notice that the Polaroid SLR 680 is bigger and heavier than the SX-70. The built-in electronic flash, sonar transducer (gold circle in the middle), and the auto-focus override switch are all housed in the large rectangular piece that sits above the lens when the camera is open.

Opening The SLR 680 opens the same way as the SX-70 camera does: pull the small end of the viewfinder cap upward and the support arm on the side will lock into place.

Loading the Film Loading and unloading is very similar to the SX-70 except that you are using 600-speed film. Push down the yellow tab on the side of the camera to open the film door. With the small tab facing out, slide the film into the camera until you hear the click and then close the film door. The dark slide/film cover will automatically eject.

Adjusting the Settings The flash indicator and on/off switch are located at the back of the camera in the right-hand corner of the flash housing. The red light will indicate that the flash is charging; when it goes off, the flash is ready to be fired. If you choose to keep your flash turned off, turn the switch to the lightning bolt with the line through it; remember to check this setting each time you open your camera, as the button can easily be pushed to the on position by accident.

Use the exposure dial to lighten or darken your image. We suggest leaving it in the middle for your first shot and then adjusting the dial if you need more or less light.

You can choose to use manual or automatic focus. If you do not wish to use the auto-focus, simply push down on the narrow black button on the front of your camera directly above the focusing

wheel. Once the button is pressed, you'll see a red line indicating the auto-focus is off. You can now use the focusing wheel to focus your images.

Taking the Picture and Unloading the Film Hold this camera in the same way as the SX-70, remembering to keep your fingers away from the exit slot, the front of the camera, and the bellows. If you are using the auto-focus feature, press lightly on the shutter button to preview your image, being careful not to fully depress the button and accidentally expose the shot. If you don't like where the focus is falling, let go of the shutter button, recompose your shot, and preview again. When you are happy with your composition, push the shutter button all the way down to take the picture. After taking the last shot in the pack, you'll find that the 680 models unload in the same fashion as the SX-70 and 600 model cameras.

Taking close-ups: Polaroid's SLR cameras are perfect for shooting close-up pictures as they can get as close as 10 inches from a subject, making them an ideal choice for instant still life photographers.

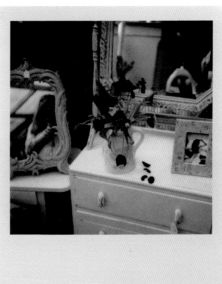

What we love: We adore these cameras because they have much of the beauty and power of the SX-70 but also give you the ability to shoot with auto-focus and 600-speed film. Polaroid took all that was good from its beloved SX-70 camera and made it a little more modern. The only downside to any Polaroid auto-focus camera is that it's going to be heavier and take up more room in a bag, but that's a small price to pay.

Polaroid Spectra

Years of Release: early 1980s–early 2000s

HISTORY

Sleek and modern-looking, Polaroid's Spectra cameras were made with higher-quality lenses than the standard 600 cameras and came with extra features such as self-timer switches and flash. During a twenty-year period, Polaroid released a series of Spectra cameras, each with only slight variations in function. The Spectra Pro has manual focusing and multiple exposure options, making it highly desirable; the rare Spectra Onyx was built with a transparent casing. In the early 1990s, the Minolta company created the Minolta Instant Pro camera, which is essentially the same as the Spectra Pro. The Spectra 1200FF resembles a folding SLR camera with opening

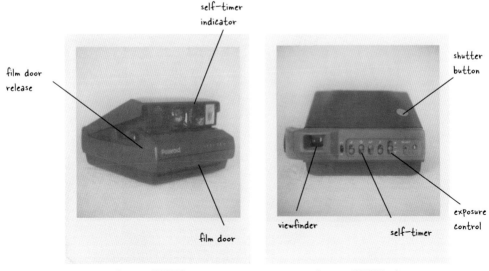

Spectra 1200FF front Spectra 1200FF back

and closing bellows, although it is nothing like an SLR in function and use.

The introduction of Polaroid's Spectra cameras also saw the release of a new integral film—Spectra (also known as Image/1200) film was larger in size and rectangular in format. The Impossible Project now produces PZ 600 film for Spectra cameras.

FILM
Spectra/Image/1200 Polaroid film, Polaroid Softtone, Impossible PZ 600 Silver Shade, and PZ 600 Color Shade.

BATTERY
These cameras do not require separate batteries, as a disposable battery is contained in the integral film pack.

BEST LIGHTING SITUATION
Spectra film has a rating of 600 ISO and looks similar to Polaroid 600 film. Designed to be used both indoors and outdoors with the flash, these cameras work best in sunshine and light cloud cover with the flash switched off; the flash can also be turned off for use indoors as long as there's enough light from a window or door.

FUNCTIONS AND CAMERA USE
Please note that we'll be discussing the original Spectra/Image cameras in this guide. The more modern 1200FF has slightly different functions for opening and closing.

Opening Most Spectra cameras have a release latch on the left-hand side for opening. Hold the camera underneath with both hands and slide the latch backward—the top part of the camera will spring open to reveal the lens. To close the camera, slide the latch again and push the top part of the camera back down.

Loading the Film On the opposite side to the release latch is the film door release. It is indicated with a down arrow and is only visible when the camera is in the open position. Press the film door release and the film door will drop open. Slide the Spectra film pack into the film compartment until you feel it snap into place and then close the film door.

Adjusting the Settings The viewfinder and the control panel are at the back of the camera. On the control panel, you'll see six different settings plus the remote charging light and the film counter. You can control the auto-focus, the flash, the self-timer, and the exposure (black and white arrows). The other two settings simply turn off the musical chimes and change the distance measured in your view-finder from feet to meters (FT/M).

Taking the Picture Slide your left hand up through the strap, with your fingers resting on top of the camera and your thumb under-neath. Your right hand will grasp the other side of the camera the same way, with your index finger over the shutter button.

For best results, Polaroid recommends placing your subject between 3 and 5 feet from your camera. When you press the shutter button halfway, a number and symbol will appear in the view-finder—the number indicates how far away your subject is in feet or meters and the symbol indicates the quality of the picture you are about to take. The green circle indicates a good picture, while the flashing yellow triangle is a warning telling you to adjust your settings. You may be too close to your subject or your subject may be too far away from the flash.

The auto-focus system relies on the subject being in the middle of the frame and will focus on whatever is there, so be aware that the camera may focus on objects in front of your subject. You can choose to keep your subject out of the center of the frame by focusing

and then reframing—place your subject in the center of your frame, press the shutter button halfway down to lock the focus, recompose your image to include the other elements within the frame, and then press the shutter button all the way down to expose the shot.

You can turn off the auto-focus altogether on the control panel. The lens will default to a distance setting of 15 feet (4.6 meters) for outdoor images.

Unloading the Film To unload the film, simply open the camera, press the film door release, and pull the film pack out of the camera using the paper tab. The film counter will count down until the pack is empty.

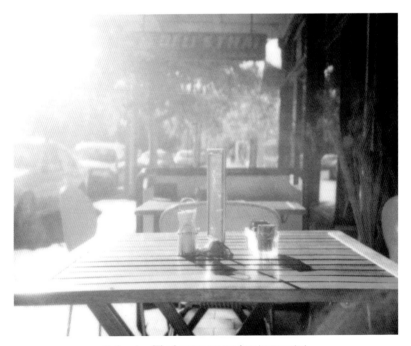

What we love: "The Spectra can produce images similar in tone and color to Polaroid 600 film used with the SX-70. I love how my shots appear sunny and aglow. It's a great summer camera." — *Amanda*

Fujifilm Fuji Instax (Mini and Wide)

Years of Release: 1999–present

HISTORY

The Fuji Instax camera was originally released as the Fujifilm Instax 100 in the 1990s and produced an instant image roughly the same size as Polaroid's 600 film. It was subsequently replaced with the 200 model, and then the current 210. The Instax also comes in a smaller size that produces images roughly the size of a credit card.

FILM

Fuji Instax Mini (Instax Mini 7, Mini 25, Mini 50s cameras) and Instax Wide (Instax 200/210).

BATTERY

Standard AA batteries.

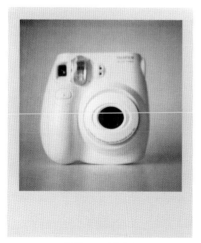

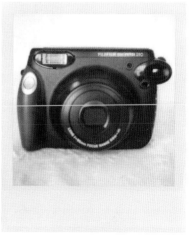

Fuji Instax Mini 7s Fuji Instax Wide

What we love: These cameras capture the spirit of the original Polaroid 600 cameras. They're fun, no-fuss cameras made for happy shooting and are ideal for children who want to explore the magic of instant photography. We also adore the fact that film is readily available in most camera stores.

Example from the Instax Mini

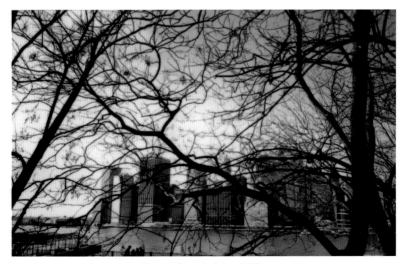

Example from the Instax Wide

BEST LIGHTING SITUATION

Fujifilm designed the Instax to be a flash camera and as a result the flash cannot be switched off. The Instax works well both indoors and outdoors on sunny and cloudy days. We recommend a bright day with cloud cover for overall tones that are soft and creamy. Your indoor images will be shot with a much harsher light, as the flash always fires. We suggest taping over the flash with some semi-opaque masking tape to soften the light from the flash. However, you may find that you need full sun in order to achieve even exposure.

FUNCTIONS AND CAMERA USE

The Fuji Instax is a very straightforward camera to use and functions much like the 600 series Polaroid cameras. Make sure your batteries are loaded in the battery compartment on the side of the camera.

Loading the Film, Adjusting the Settings, and Taking the Picture Open the back of the camera, slide the film pack in, close the door, and the film cover will eject from the top of the camera. To power the Instax Mini, simply pull out the lens, and the power indicator will flash red until green. It is ready to shoot. You can adjust your exposure settings by choosing indoors (indicated by a house), cloudy, sunny, and very sunny. The Instax Wide has a lighten and darken control for exposure adjustments.

Look through the viewfinder and press the shutter button. The instant image will start ejecting from the top of the camera.

POLAROID AND INSTANT FILM

Polaroid made two types of peel-apart film: 80 and 100. The 100 type was more common and was used in most consumer cameras. Additionally, now Fuji makes color and black and white 100-type

film as well as 3000-speed black and white for use in peel-apart cameras.

Polaroid made three different integral films: SX-70, 600, and Spectra. The Impossible Project is currently making its own variations of these three films. Polaroid stopped producing these films in 2008, and while there is still some film available on the market, do bear in mind that it will be long past its expiration date, potentially resulting in distorted colors and/or battery failure. Integral instant images should NOT be shaken while they are developing, and in temperatures below 55°F (13°C) should be placed inside a pocket to keep warm.

Polaroid had a rather confusing labeling system for its films. The 100-type films used in peel-apart film cameras are mostly numbered within the 660 number range; for example, 667 and 669. However, do not confuse these with the 600 film used in Polaroid 600 cameras. Polaroid 600 film is integral film and can be used only in 600 cameras or modified SX-70 cameras. Polaroid had originally named the 100-type series film differently, but changed the numbers to the 660 range in the 1970s. Below you will find a list of films categorized by film type. As previously stated, many can still be located on the market if you spend a little time digging.

100-type films: Fuji FP-100B, Fuji FP-100C, Polaroid 664, Polaroid 665, Polaroid 667, Polaroid 668, Polaroid 669, Polaroid 690, Polaroid ID-UV, Polaroid 100 Chocolate, Polaroid 100 Blue, Polaroid 100 Sepia.

80-type films: Polaroid 84, Polaroid 85, Polaroid 87, Polaroid 88, Polaroid 89, Polaroid Viva Color, Polaroid Viva BW, Polaroid 80 Chocolate.

600-type films: Polaroid 600, Impossible PX 600 UV+, Impossible PX 600, Impossible PX 600 Silver Shade FF, Polaroid 779.

SX-70 films: Impossible PX 70 Color Shade, Impossible PX 100 Silver Shade, Polaroid SX70 Fade to Black, Polaroid Artistic TZ, Polaroid Time Zero, Polaroid SX70 Blend, and Polaroid 600/779 with manipulations.

Spectra: Polaroid 1200, Polaroid Spectra, Polaroid Spectra Image, Polaroid Softtone, Impossible PZ 600 Silver Shade, Impossible PZ 600 Color Shade.

Other Polaroid types: Polaroid 300 (Polaroid 300 cameras), Polaroid 500 (Polaroid Joycam and Captiva cameras), Polaroid Izone (Polaroid Izone cameras), various Polaroid 4 x 5 films for use with large-format photography.

Fuji Instax: Fuji Instax Mini (Fuji Instax Mini 7, Fuji Instax Mini 50S, Fuji Instax Mini 25), Fuji Instax Wide (Fuji Instax 210-wide angle).

POLAROID AND INSTANT CAMERA ACCESSORIES

Polaroid created a variety of accessories to use with its instant cameras, from close-up and colored filters to the essential remote shutter button.

SX-70 AND 680 ACCESSORIES

Polaroid produced an accessory kit for its SX-70 cameras, comprising an accessory holder, lens shade, remote control shutter button, tripod mount, close-up lens, and flash diffuser. We especially love using the close-up filter to get extra-close to a subject, and the remote control shutter trigger is always useful in low-light situations where camera shake is likely. The end of the cord plugs into two small holes

on the right-hand side of your camera, near the shutter button. Be sure to focus on your subject before pressing the red remote button.

CAMERA CASES

Original SX-70 tan leather cases can still be located on eBay and at vintage stores and are often included with cameras sold in their original boxes. Options include the classic leather pouch adorned with *Polaroid SX-70* on the front and the "ever-ready" version, a specially designed leather case that fits around the camera when open and closed. Additionally, with the growing popularity of the medium, artisans and retailers alike are creating new cases crafted specifically for these cameras.

SPECTRA ACCESSORIES

The Spectra camera system included a wireless remote shutter powered by 9-volt batteries and other accessories including various close-up filters and camera stands.

POLAROID BACKS

Polaroid backs clip onto the back of medium-format and large-format film cameras to give them instant-film functionality. Originally used by professional photographers to test lighting setups and check exposure before loading the camera with film, the backs take both Polaroid and Fuji peel-apart film.

HOLGAROID

Holga camera + Polaroid back = Holgaroid!

A Holgaroid is comprised of a Holga camera fitted with a Polaroid back. Originally designed to take the (now discontinued) Polaroid 80-type film, Holgaroids are now made to fit Polaroid 669/690 film and Fuji FP-100C/100B film. You can find them at Freestyle Photo and the Impossible Project (check the Resources chapter).

WHERE TO BUY

Many of these accessories can be sourced on sites such as eBay and Craigslist. We've found Polaroid items at yard sales, antique stores, secondhand stores, and camera markets. Be sure to check out your local thrift and antique stores. Many stock cameras and photography accessories can be found for surprising deals.

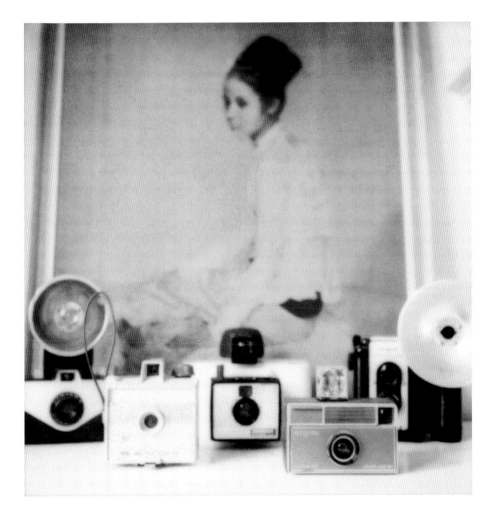

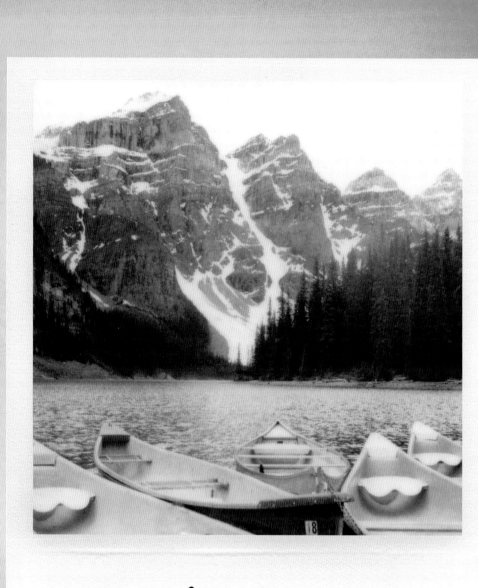

Chapter Two

THE ART OF COMPOSITION

Think of composition as if it were the foundation of a house, the framework the other elements of the image—the mood, light, and emotion—hang on. A strong composition invites the viewer into the scene while telling a story with shape, color, and expression. Simply put, composition is the way the subject of a photograph is placed within the frame. The rules of composition can be learned—and we'll be looking at them in-depth in this chapter—but in our experience, practice is the greatest teacher of all. Shooting instant film brings its own considerations with it, not least of which is the price of film. Unlike digital photography, we can't shoot hundreds of shots in the hope of nailing "the one." When shooting Polaroids, precision is paramount, and that can be intimidating for the first-time shooter. However, by learning a few basic rules of composition, you will undoubtedly produce gorgeous shots every time.

While your camera's capabilities will understandably dictate many facets of your picture-taking, composition is the one aspect controlled entirely by you. What you choose to shoot and how you choose to shoot it is how you'll develop your voice as an artist and share your vision with the world. Recognizing a strong composition is an intuitive skill and the result of keenly observing the world around you. As you practice visualizing objects, people, and light with your photographer's eye, you'll find you start noticing pleasing

compositions wherever you go. Remember, as the photographer, you are so much more than the person who takes the photograph: you're also the curator, the stylist, and the storyteller.

In this chapter, we'll explore the rules of composition, how these rules can be applied to different subject matter, and how they can ultimately be broken. Familiarity with compositional rules is a good place to start, but never let the rules stifle your initial vision or detract from the emotional response you have to a scene—trust your gut instinct when you have a Polaroid camera in your hands! We'll also discuss the power of perspective, ways to frame your subject, and how movement and balance add depth to an image. We'll touch on the way light plays into your composition, your subject choices, styling, and how to develop a story through every Polaroid you compose. Finally, we will guide you on ways to apply all of this to one of the most challenging subjects, the portrait.

THE RULES

It may sound obvious, but the first and most important rule in instant photography is to compose your photograph before you hit the shutter button. Putting careful thought into your composition and choosing what to include (and what NOT to include) is the first step toward creating a strong image. So how do you decide what to include? Photography is a visual art, and the rules that apply to painting and drawing can also be utilized when creating a composition with a camera . . .

THE RULE OF THIRDS
The Rule of Thirds is an imaginary grid of two horizontal lines and two vertical lines placed over an image to create nine equal

sections. Ideally the primary subject of your photograph should line up with one of the lines or rest on one of the four points where the lines intersect.

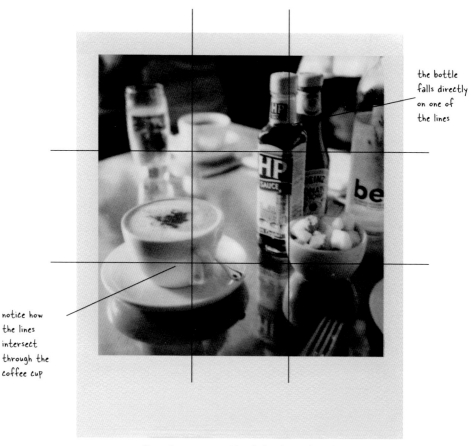

the bottle falls directly on one of the lines

notice how the lines intersect through the coffee cup

"It made sense to position the bottles on the right-hand vertical line, leaving the cups on the left-hand side, filling the frame without overwhelming the eye."
— *Susannah (camera: SX-70)*

Rule of Thirds

Consider the Following:

1. Originally a rule in painting theory, the Rule of Thirds is especially useful when shooting landscapes; try placing the horizon on either the upper or lower horizontal line of the grid to immediately give your image more impact. (To test this out, try placing the horizon squarely in the center of your frame for comparison—which shot is more interesting?)

2. Because our eye tends to enter a photo or painting from the left and move across to the right, you'll find that placing the primary subject of your shot in the right third of the grid often produces the most pleasing results.

3. When photographing a person, try placing them in the center of the frame, ensuring their eyes line up with the upper horizontal line of the grid.

4. As you look through the viewfinder, imagine the grid lines over your frame and place your subject accordingly. It may help to move your camera up and down as you look to help identify the best points within your imaginary grid.

"I moved to compose this shot using the Rule of Thirds as I didn't want Sean to move from the position he was in—it was so perfectly him. I feel I captured the essence of him that day."
— *Amanda (camera: SX-70)*

Breaking the Rule of Thirds Once you have successfully grasped the Rule of Thirds, it's time to break it. We challenge you to create an artful composition while throwing this concept out the window. Explore the angles you're shooting and pay attention to how you're cropping your image. Visualize the lines, and pan your camera as you look through the viewfinder, moving your subject away from the lines before you point and shoot.

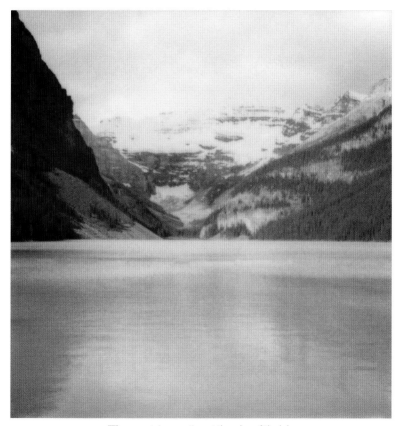

"The mountains meeting at the edge of the lake
seemed like a natural place for me to center
my image. The scale of the mountains would have
been lost if I'd used the Rule of Thirds."
— *Amanda (camera: SX-70)*

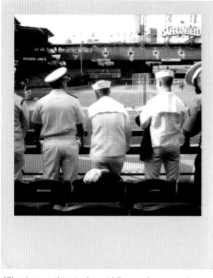

"The three sailors in the middle caught my eye imme-
diately. I love the story it creates—what better place
to welcome them home than a baseball game?"
— Amanda (camera: 680SLR)

THE RULE OF ODDS

Objects grouped into odd num-
bers tend to be more visually
interesting than evens. Whether
you're photographing people,
windows, or even pieces of fruit,
shoot them in threes rather than
twos, fives rather than fours.
And be sure to pay attention to
your background. If your com-
position has a single subject in
the foreground, look for pat-
terns of threes or fives in the
background.

Breaking the Rule of Odds There
will obviously be situations when
this rule won't apply. When shoot-
ing couples, for example, we
encourage you to embrace sym-
metry and balance, for an even
number of objects can be just
as powerful when styled with a
clear vision in mind.

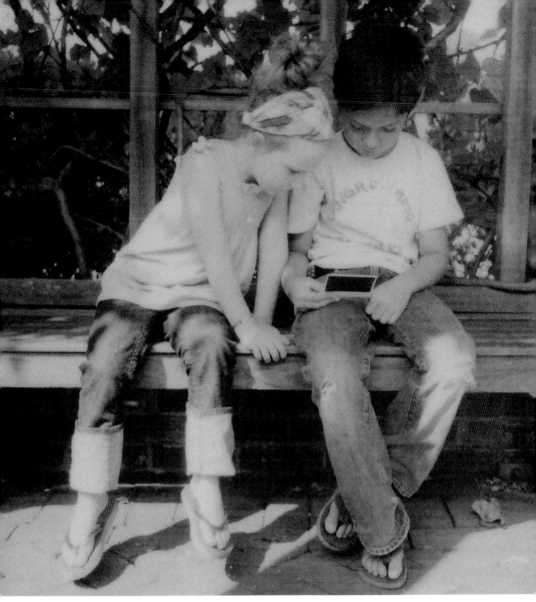

"This never felt like breaking the rules, the two of them fit perfectly within the frame and their body language only added visual interest." —*Jen (camera: 680SLR)*

DEPTH OF FIELD

In photography, the depth of field (DOF) is the portion of the scene that's in focus in the photograph. When shooting landscapes, it's preferable to have a large DOF that takes in everything from the camera all the way to the horizon; in portraiture, a shallow DOF is often favored, keeping the subject in focus in the foreground while the background is out of focus to minimize distractions.

Several factors allow control over the desired DOF, including your physical proximity to the subject, the focal length of your lens, and the aperture setting (f-number) you choose. As the SX-70 and SLR 680 are SLR cameras, you have the ability to get close to a subject and take advantage of the large aperture (small f-number)

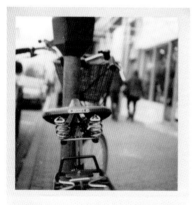

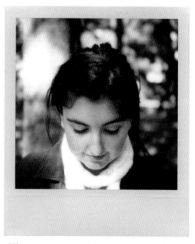

"I could have shot from my natural eye level, but chose to crouch down low to the bike's level to focus on the seat and create the beautiful and shallow depth of field behind it."— *Amanda (camera: SX-70)*

"She was serene and happy, and I wanted to keep the focus on her face and expression, so I captured her up close to create a shallow depth of field." — *Amanda (camera: SX-70*

of the camera. The SX-70 can get as close as 10.4 inches (26cm) to the subject; this results in a pleasingly blurred-out background as the DOF drops away (the blur is often referred to as *bokeh*). This type of shot is especially effective when you want to capture the smaller details in a still life, such as flowers in a vase or a glass of champagne on a table.

Note: Newer models of both Polaroid and Fuji cameras do not allow for this sort of control and are usually preset with a small aperture (large f-number), resulting in almost everything being evenly focused within the frame. For more detailed information on depth of field, check out our recommended photography books in the Resources section.

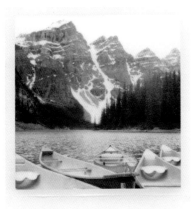

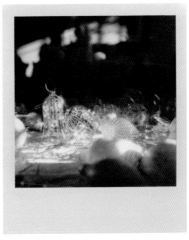

"The canoes, lake, and mountains were all equally important elements in this scene, so I wanted a deep depth of field to ensure everything was in focus."
— *Amanda (camera: 680SLR)*

"The light hitting the baubles was coming from a narrow window on the right. The small pocket of light created a beautiful contrast between the illuminated ornaments and the darkness behind them."
— *Amanda (camera: SX-70)*

PERSPECTIVE

Perspective relates to focal length of a lens and the way a scene can be manipulated to create more depth. Ordinarily, a scene can appear to be larger or smaller, or closer to or farther from the camera through the use of different lenses. As Polaroid cameras do not have detachable lenses, perspective is created in more subtle ways. By identifying the light and dark in a scene, we can manipulate the way an image looks. For example, a light foreground subject against a dark background immediately adds a sense of depth to a shot.

Perspective also refers to the angle and viewpoint from which the photograph was taken. By changing your position as you compose your shot, you have the power to manipulate the final image. For example, standing on a chair and looking down at a sleeping cat creates a sense of the distance between the viewer and the cat, while lying on the floor next to that cat creates immediate intimacy

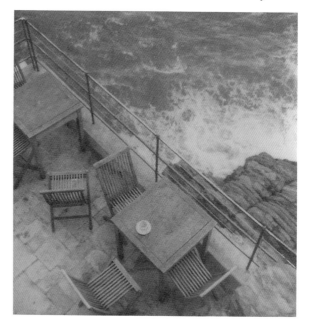

"Looking over the pathway that linked two of the villages in Cinque Terre, I found this beautiful little spot. It challenged my use of perspective and gave me a wonderful opportunity to capture a familiar scene in an unfamiliar way."
— Jen (camera: SX-70)

and a "cat's-eye view." It's the photographer's job to try every angle when telling the story, as another viewpoint may completely alter the feel of your shot, often for the better. A close-up of your subject captures more emotion, while shooting from behind or from afar lets the viewer feel they are peeking into another's private world, a very different type of intimacy.

Using a wide range of perspectives in your photography will help you create a body of work that's unique and vibrant. Don't be afraid to take a few risks to get the shot you want; if the better angle means you have to lie down on the ground, then kick away the leaves and go for it!

FRAMING

Instant films come in a few different sizes, but if you're shooting with integral film, this may be the first time you've composed square images. While the Rules of Thirds and Odds apply whether your final image is square or rectangular, in many ways a square frame appears more self-contained, the four (almost) equal sides seemingly primed for a centered subject. But a frame can be so much more than the edge of the photograph. Consider including frames *within* your frame, lines and shapes that frame your subject and draw the eye deeper into the photo—the branches of a tree, the lines of a building, a window, or even a door frame. For example, let's say you want to photograph your daughter reading in her room. You could shoot her close-up with beautiful light around her, creating a warm and friendly scene. However, if you were to step outside the room, using the partly closed door as a frame, the story suddenly becomes far more intimate, the viewer now looking in on the child who's lost in her own world, possibly reminded of similar days from their own childhood.

THE COMPOSITION FRAME CARD

Utilized by photography teachers the world over, a composition frame card is a useful tool for practicing your composition skills before you shoot the film in your camera. Cut out a frame card the size and shape of a white polaroid border. Hold the frame in front of the scene you'd like to capture—what will you include in your shot, and what should you leave out? Do you need to get closer or move farther back? Stand higher or lower? Is there anything you could take out of the scene to bring more harmony to the overall shot? Practice looking at the world in squares; you'll soon find you're seeing potential shots everywhere you go.

POSITIVE AND NEGATIVE SPACE

Positive space refers to the subject of your image, while negative space is everything else around it. In art school we're encouraged to draw the negative space around a subject as another way to capture its true shape, so try this with your photos, considering the negative space first, before positioning the subject. The negative space gives the viewer's eye a place to rest while it supports the main subject. Sometimes the negative space becomes the subject itself, creating a beautifully minimalist composition: think wooden docks jutting out into a lake or a single sunbather lying on an otherwise empty beach. Try shooting the same scene a number of times, altering the amount of negative space in each shot by adjusting the distance between the camera and the subject and decide which composition makes the biggest impact—more negative space or less?

On the other hand, try filling the entire frame with your subject, removing all the negative space. By throwing out the rules and exploring the angles and proximity in which you shoot, you can achieve beautiful results that are akin to abstract art. Check out

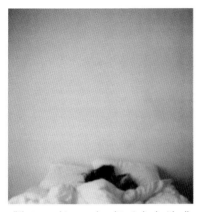

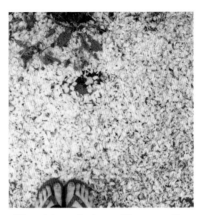

"Photographing my daughter in bed with all of the negative space above her creates more overall visual interest in this composition."
— Jen (camera: 680SLR)

"The petals are the focus of the composition yet the inclusion of my feet turns them into negative space, adding a sense of scale."
— Susannah (camera: SX-70)

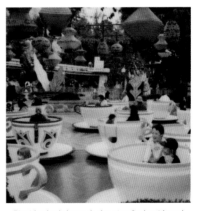

"The even quantity of positive and negative space makes a harmonious balance between grass and sky." — Amanda (camera: 680SLR)

"As I looked through the viewfinder, I loved everything from the hedges to the lanterns above, so I filled the entire frame with this colorful scene." — Jen (camera: 680SLR)

Grant Hamilton's abstract Polaroids on page 76 for some striking examples of minimalist abstract compositions.

CROPPING

These days photo-editing software makes it very easy to crop digital photographs after they've been shot. However, when shooting Polaroids and instant film, it's better to practice cropping "in camera," carefully composing the shot through the viewfinder, removing the extraneous elements of the scene by moving closer to your subject or changing your viewpoint. Instant film can be digitally scanned and cropped later, of course, but holding a well-composed Polaroid in your hand is always very gratifying, so take your time when composing your shot.

MOVEMENT

In the visual arts, movement can refer to the actual physical movement of the captured subject or the movement of the viewer's eye as it travels through the composition. Not being able to control the shutter speed and aperture of your instant camera makes capturing physical movement challenging, but not impossible. Using a tripod to keep the camera still, combined with careful timing of the shot, will help you catch the twirl of a skirt, children at play, or the energy of a carnival ride.

To create compositional movement within your shot, look for curves, geometric shapes, and flowing lines that take the eye in a certain direction through the image. Movement can be as literal as a winding road moving through the scene or as subtle as a tendril of hair falling across your subject's forehead.

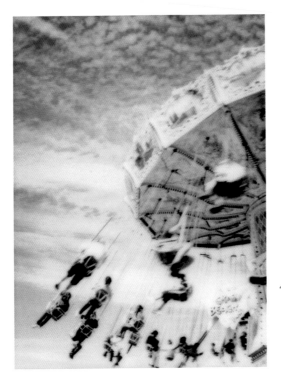

"The movement of the people on the ride adds to the story—you know they are having the time of their lives as they soar through the air." — *Amanda (camera: Fuji Instax Mini 7s)*

BALANCE AND UNITY

When experimenting with the Rule of Thirds, it's possible to move your subject from the center of the frame and be left with too much negative space. To compensate, try adding other, secondary objects to your composition to create a sense of balance within your frame. Unity is achieved when all the photographic elements come together into one harmonious scene, creating a pleasing balance of light and dark, lines and shapes, movement and stillness within the shot. In time you'll uncover your own sense of what qualifies as unity in your own work.

LINES AND SHAPES

At its simplest, consider your photograph to be a series of lines and shapes working together to create a picture. Long or short, thick or thin, lines and shapes are everywhere around us and provoke different responses in the viewer. Curved lines appear natural and friendly, while sharp, jagged lines can suggest danger and discomfort. Diagonal lines evoke movement and action, while straight lines appear more fixed and rigid.

PATTERNS

Patterns appear in both natural and human environments and give your photos a sense of structure and movement as the eye naturally follows the pattern in an image. Look out for man-made patterns like mosaics and unusual brickwork; natural patterns occurring in leaves, flowers, and shells; and incidental patterns found in repeated shapes—a table laid out with plates, bagels, sliced lemons, glasses, and mugs becomes a table filled with repeating circles. Patterns can be subtle, or obvious, as in the accompanying photos.

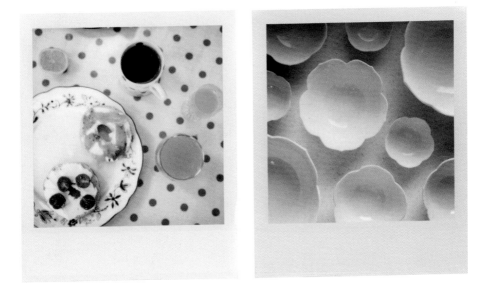

TEXTURE

Texture gives a photograph emotion, helping the viewer imagine the roughness of tree bark, the nubby texture of linen, crunchy leaves underfoot, or swirling ice on a windowpane. Try shooting texture using low side-lighting to accentuate the details and give a delicious tactile quality to your shot.

SYMMETRY

Because the human body is symmetrical, our eye is naturally drawn toward symmetry both in nature and in the constructed world. Buildings and architecture immediately spring to mind, but look out for symmetry in the natural world too: a tree-lined road, blooming flowers, and reflections in still water are timeless images made extra-special on instant film. Mirrored lines and shapes pull us inside the photograph, so explore symmetry in your

tabletop arrangements, filling your square frame with even designs and patterns.

ASYMMETRY

Once you've nailed symmetry in your Polaroids, it's time to mix it up a little. We love shots that veer toward symmetry but have one or two elements unexpectedly breaking the pattern—it's a surefire way to keep the viewer's eye interested and awake.

COLOR AND ABSTRACTION

There's real-life color, and then there's Polaroid color, and rarely do the two ever meet. One of the joys of shooting instant film is the unpredictable nature of the film. From the retro feel of expired 600 integral and the soft tones of Spectra's Image film to the green-hued delights of Artistic TZ, different effects can be achieved with different films. Each type of instant film has its own unique chemical composition; some will capture color as it appears to the eye, while others capture color in a more impressionistic manner. Then there's the light to consider: sunsets give your shot a rich orange tinge, while a bright, white room produces delightfully soft, milky hues.

Of course, the colors of the subjects you choose to photograph will also affect the mood of the photograph, so it's worth

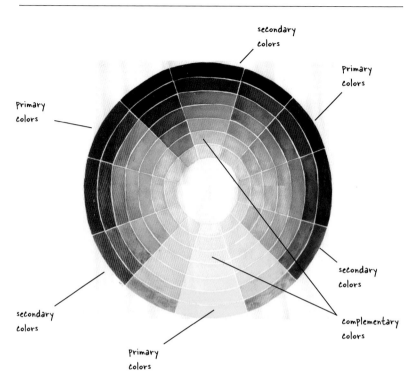

familiarizing yourself with the rules of color theory. Notice how colors are grouped together on the illustrated color wheel above: primary colors (red, blue, yellow) mixed together create the secondary colors (purple, green, orange), while the colors sitting opposite each other on the wheel are considered to be complementary—if you see yellow and purple together, shoot it!

Grouping similar colors together creates harmony within an image, and thoughtful use of color will provoke an emotional response in the viewer; for example, red is a bold, powerful color that evokes passion or anger, while greens and blues feel much more calm and serene.

Color can also be the focal point of your entire composition. Polaroid artist Grant Hamilton is well known for his striking abstract imagery, so we asked him to share some of the secrets of his picture-making process with us:

For me to make a photo, there are several things that have to happen. First, I need to have bright sunlight—without that, the colors won't be right and I don't even bother. Second, I must find a subject. For me, the most fertile locations are strip malls and the sort of commercial development that permeates suburban America. I'll drive around looking for bright colors and patterns that are near ground level. If I can't reach it, I can't photograph it. Once I find something interesting, the sun has to be over my shoulder at approximately a 45-degree angle. The surface of the subject can't be glossy or I'll end up with an impressionistic self-portrait.

Once all of this is in place, I will look at the subject through the viewfinder and move around and back and forth to get some ideas about composition. Much of what I do depends on strict alignment, which often constrains things. To compose a photo that has elements aligned with the edges of the Polaroid frame, I can't be at the minimum focusing distance as the lens on the SX-70 has a tendency to pincushion when shooting close-up, making the straight lines into curves when they are near the periphery.

After that is sorted out, I'll take a moment to just hold still. I don't use a tripod, so it can be very difficult to get the image perfectly level. Before pressing the button, I make multiple checks in the viewfinder, making sure that I am centered, not "keystoning" (when I am not perfectly parallel to the subject), and that other compositional elements are where they should be. Sometimes I have an edge exit the frame right at the corner, so that requires a lot of double-checking right before pressing the button. By shooting like this, I don't waste much film. Often I only need to make one exposure. All of this gets more challenging if I am shooting something that is about to move, like a bus at a stoplight, for example.

Impossible by Grant Hamilton

Super Awesome by Grant Hamilton

Philosophically, what I am attempting to do is edit everything out of the frame that I don't want to see. Part of what motivates me is to find something beautiful that others have seen but never noticed—like part of a gas pump or a construction barricade. Through my photos, I strive to find beauty in the mundane. It is hard to describe to passersby why, exactly, I am photographing the side of a bus or standing on a ladder on the side of a road, trying to reach a sign. Most of the time, however, people will see the beauty that I am seeing and will smile. Often they will remark that they never noticed that before.

I use Polaroid integral film for several reasons. Besides being a singular image, each is a unique object and the mechanical process of spreading the chemicals over the exposed image imparts a painterly quality that can't be simulated. Also, since each photo is self-contained, I can only control composition and exposure in the camera.

LIGHTING

Lighting is definitely the secret ingredient to creating a stunning, knock-your-socks-off Polaroid, and just like color, light can significantly alter the mood of your photo. Picture this: after a warm, crumpled sleep, you lead yourself to your kitchen, where the first light of the day is bouncing warmth into the room like a morning

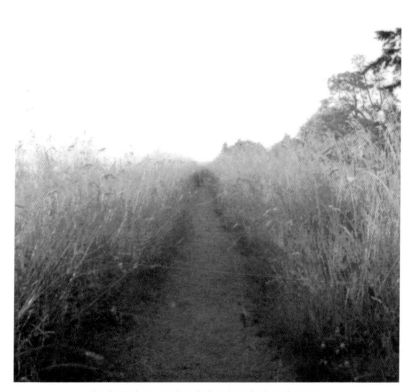

"Walking along a path to the beach, in the late afternoon,
I noticed the softness of the light that was washing over the
grass." — *Amanda (camera: 680SLR)*

embrace. It's soft, gentle, and full of grace. That's the light that you'll learn to notice, to seize, to embrace. That's the light that magical Polaroids are made of.

We'll discuss the importance of light in detail in the next chapter, but remember that observation is key. Whether you're home, in the park, or at your favorite café, you should know where the light falls and when. Become an observer in your own home and discover when best to shoot and how to utilize what you have around you. Over a week, study where and how the light falls in your home; look for morning light about one to two hours after sunrise and then afternoon light one to two hours before sunset. Harsh midday light streaming into your living room will not provide you with the light you most likely seek. It needs to be soft and gentle.

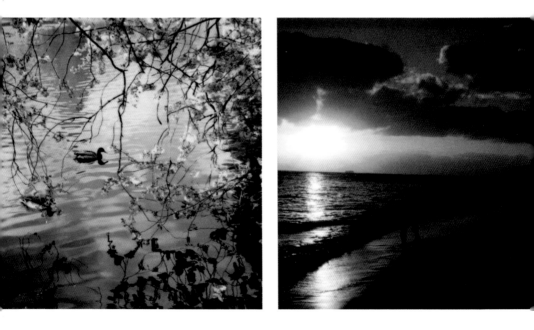

As you look through the viewfinder of your camera, be aware of how the light is affecting the composition. Is it casting strong shadows beneath your subject? If so, move to the shade to avoid overhead light. Is the subject itself aglow? How does it affect the mood of not only your subject, but the entire composition? Natural, even light will create an inviting, warm image, whereas darker scenes create a more atmospheric tone. Additionally, be aware of where you place yourself and the camera when composing your shots: if you move to a different position, does it give you better light? If you're shooting a landscape or street scene, shoot when the light is good; if you're shooting a portrait or a styled scene in the middle of the day, move your subject to the shade to avoid harsh shadows cast across your image.

USING THE LIGHT

The use of reflected light is a time-honored way to bring a photograph to life. Mirrors and glass will literally reflect the light back to your lens, adding a pleasing glow to portraits and self-portraits. Watch the way the light bounces around your home, reflected in steel appliances, cutlery, holiday ornaments, bathroom taps, and monitors. Head outside after a thunderstorm to find puddles filled with reflected clouds; sit by a lake and marvel at the way the morning sunlight transforms the still water into a huge mirror, a scene just begging to be shot on instant film.

Silhouettes are another wonderful way to play with the light in your shot. Try placing your subject directly between your camera and any bright light source—this could be bright light coming into a darker room from a window or door, the rising or setting sun, or even bright artificial light.

"These cupcakes were displayed in the
window of a shop selling the most beautiful
cupcakes I've ever seen—I was so
thankful I had my SX-70 with me!"
—*Susannah (camera: SX-70)*

SUBJECT CHOICE AND STORYTELLING

From a beautiful necklace to a humble egg in a bowl, just about anything looks good when it's captured in a Polaroid; luckily your own innate curiosity will pull you toward the images your heart wishes to make, whether they're snapshots of your everyday life or self-styled still lifes.

Saving your instant-film experiments for the subjects you really care about will help to infuse real emotion through your photos. If you happen to have a soft spot for cupcakes and love to photograph them whenever you get the chance—do so with instant film! They don't have to be special cupcakes, but they do need to look especially delicious. Position the cupcakes so they're surrounded by soft light, and add a crumpled napkin or a dessert fork to add a bit of interest. Just as you're eager to sample the cupcake, you want the viewer to feel that too, so make the cupcake the focus of the shot while using the supporting elements to enhance the story you're telling in the photo.

And here's a secret: we don't shoot Polaroids to capture a true reflection of life around us; rather, when we shoot our Polaroids, we know they will become a part of the story we tell. That narrative includes the way the film captures light and the way the lens interprets the scene—all of this is taken into consideration when we create our images. We also love the idea that the stories we are creating could have been told many moons ago. Now that the digital photography revolution has taken place, all types of film appear increasingly retro. Instant film is surely the most retro of all, and that's why we love it.

Perhaps the most fundamental rule in photography is to *shoot, shoot, shoot.* By continually choosing different subjects to shoot and familiarizing yourself with the capabilities of your camera and

instant film, you're allowing your own style to develop over time. Pick a subject and shoot it over and over again, trying different angles, times of day, film choices, and framing. Whether you choose to photograph desserts, vinyl records, street signs, houses in your neighborhood, or vintage cars, make it yours, and above all else, make it personal.

Note: While the subject is the focus of your story, it's important to pay attention to what's going on in the background. If there are unnecessary items in the background detracting from your subject, move them out of the way; if they can't be moved, rethink your shot and change your position accordingly. Remember, the negative space is as important as the positive.

STYLE

A photographer has as many subjects to shoot as there are pebbles on a beach, yet as your style develops, you'll find yourself leaning toward certain subject choices and away from others. Style doesn't appear overnight, and it can't be forced, but we promise you it will become apparent as you continue to delve deeper into your experience of the world around you. Your style will be as unique as you are.

So what exactly do we mean by *style*? Think of it as a photographic recipe made up of your passions, the subjects you like to shoot, the places and times of day you prefer, and the way you see light and color. If you're drawn to Polaroid portraits, check out other

photographers' work (Flickr.com is a great place to start) to see how they handle the light, their favorite poses, what angles they use. We are by no means advocating copying another photographer's work, but for the first-time shooter, finding inspiration in the work of other photographers will help feed your image vocabulary and give you a place to start.

Pay attention to your passions. Are you drawn to the natural world? To buildings and architecture? Certain colors, objects, or animals? Perhaps wildflowers are your muse, or you wish to capture your friends at the beach in the summer sunshine. The more you shoot, the more your style will naturally begin to evolve as you hone and develop your photographer's eye.

WHERE TO START

So now that you have your instant camera, a stack of film, and working knowledge of the Rule of Thirds, what are you going to shoot? We suggest starting exactly where you are, in your home. Look around your house to find objects to shoot, either bringing them together on a table by a window or snapping them exactly where you find them. Photograph your breakfast or a long leisurely lunch with a friend, your favorite scarf hanging over a chair, playing cards scattered on a coffee table, bowls filled with twine, your cat's tail curling around your feet.

Start where you are.

Our favorite things to shoot . . .

JEN'S TOP FIVE

My daughters

Winter beaches

Italy

Curiosities

Love

My girls are the loves of my life. And I love the beach in the winter, it's almost haunting. I used to live in Italy so it will always be a special place to me—there is nothing like it in the world. And I love love—it's the reason we're here—to be able to capture it is a gift. I also have an obsession with science and I love photographing specimens.

SUSANNAH'S TOP FIVE

My nephew

Magnolias in full bloom

Autumnal seascapes

Branches set
against the sky

Lunch

My nephew is my biggest muse, always and forever. Then there's blooming magnolia trees in the spring, the way branches sketch across the sky, and the stillness of the beach in the autumn. And I find it impossible to have lunch with friends without first photographing our food.

AMANDA'S TOP FIVE

My sister

Shared
afternoons

Memories when traveling

The Australian
summer light

The details

My top five things to shoot are all pieces of my heart: the lines and freckles of my sister's face, the ritual of shared conversations and coffee with loved ones, the intimate details of life, the light from my Australian homeland, and the exploration of culture and people whilst traveling.

PROPS

Even if you prefer to capture scenes that are as natural and unstaged as possible, once in a while you'll find yourself standing before a table of antique silverware just begging to be shot. Just as magazine interiors are filled with artfully arranged still lifes of baubles and accessories, you too can be a stylist for the day as you pull together your own still lifes. Incorporating props into your shots encourages you to think about the Rule of Thirds, trying different compositions to find the right balance between the different elements in the shot.

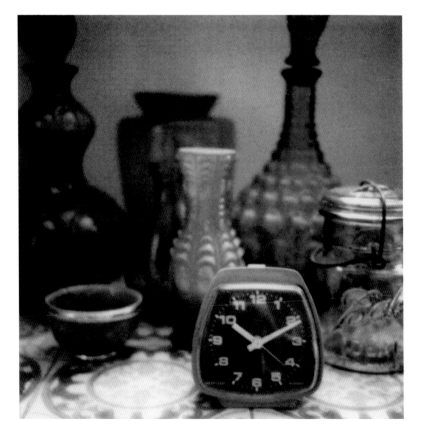

*Here are some of the props
we love to use in our compositions...*

antique whiskey flasks	milk jugs
art supplies	model planes and cars
baked goods	musical instruments
ballet slippers	old car parts
balloons	pencils and rulers
beds and pretty bedding	perfume bottles
bicycles	pocketknives
breakfasts	religious artifacts
cappuccinos and black coffee	shoes and boots
chairs	silverware
clothes	skateboards
cookbooks	snow globes
cupcakes	teapots and teacups
cushions and blankets	twigs, branches, leaves, nuts
drinking glasses	twine
fairy lights	typewriters
feathers	vases
flowers and petals	vintage books
fruit	vintage bottles
jewelry	vintage cameras
journals and stationery	vintage eyeglasses
keys	vinyl records
macaroons	vintage tools

SOME IDEAS TO TRY

Right now, in your home, is a collection of objects that mean something to you; they carry memories of other times and places, the people you love, and days gone by. Collect these objects together and

create a series of images that tell the story of your past—it could be memorabilia from high school, your first trip to Europe, your wedding day, or your grandfather's collection of vintage records. Take these treasures and place them around your home, creating little vignettes to be captured on film. Practice using the Rule of Thirds and the Rule of Odds in your compositions, and give some thought to what's behind the objects too.

Is there a special place that you love to visit? It might be a park or a beach or a local landmark that means something to you. Take your camera and a stash of film to this place and look at it again with the eyes of an instant photographer—where is the light coming from and where does it land? What colors do you see? Look for the details of this place that you could capture on film, creating evocative images that record the emotions this special place triggers in you.

Practice photographing your meals. Whether you're at home, at work, or in a restaurant, aim to record one meal a day for one whole week, trying different angles, lighting, and positions. A sandwich on a plate will look very simple compared to a Sunday roast, but whatever the meal, remember to consider the lines and shapes in your composition and the props you can see, moving items in or out of the frame to achieve the look you desire. Try shooting from different angles too: from the side, up-close to catch the textures and colors of the food, pulling back to create a story with your composition, or even standing on a chair to look down on the food. We've done this in coffee shops and restaurants alike, and yes, people may stare at you, but they'll also be admiring your camera!

Start where you are. Look up from the pages of this book— what do you see? Use a composition frame card to look around you, searching for groups of three, interesting vignettes, and unusual juxtapositions. What stories do you see? Remember, you don't need to go all the way to Paris to find magical Polaroids to shoot—there is magic all around us, we just have to stop and look for it.

Composing Beautiful Portraits

The composition tips we've shared in this chapter can be utilized when shooting portraits, too. Aside from considering composition and lighting, the most challenging part of shooting a portrait is cultivating patience. With a digital camera, you can shoot rapidly until you have an image that captures the moment you want to remember; when shooting instant film, however, that luxury is taken away. The slower shutter speeds on Polaroid cameras require your subject to be relatively still, or at the very least in slow motion. The most captivating portraits are those that catch a candid moment.

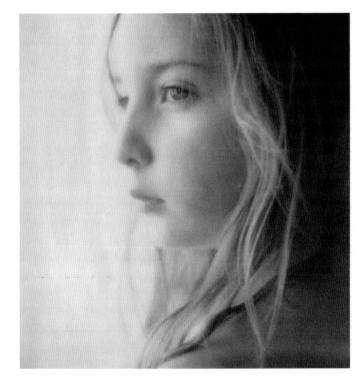

PORTRAIT BASICS

The most successful portraits are more than simply a record of what a person looks like—they're a glimpse of their personality, their mood, and their heart captured on film. Here are our top tips for shooting a classic head-and-shoulders portrait:

Find the right position. Ideally you want your model to be seated while you stand, so that their face is slightly tilted and looking up into the camera lens—this will make their eyes appear wider and more open and will gently tighten the skin on their neck. Pick a spot where the sun is behind you, preferably with a bit of cloud cover to soften the light and prevent harsh shadows on their face; if the sun's too bright, head into the shade. When shooting indoors, have your model sit facing the light source for even light coverage.

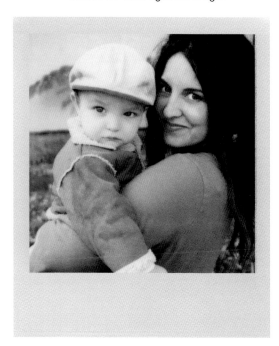

Get closer. When shooting with integral film, make full use of the square format by getting closer to your model and filling the frame, keeping their eyes the main focus of the portrait. The background will most likely be blurred out, but still pay attention to the colors, looking for shades that complement the colors of their clothes and hair.

Forget the cheese. Compose your shot, find the focus, then make them laugh to get the most natural smile.

SELF-PORTRAITS

Shooting self-portraits can feel daunting, but it's one of the best ways to practice your portraiture skills, giving you complete control over the image and a readily available model—you!

Using a cable release. The SX-70 and 680 cameras can both be used with the cable release included in the SX-70 accessories kit. You can also find self-timers for the SX-70 and battery-powered remote controls for Spectra cameras. Set up your camera on a tripod, remembering that a tripod can be anything from a low wall to a stack of books on a table. Next, get behind your camera to compose your shot and set the focus—it's best to place an object where you intend to be in the photo so you have something to focus on. Then take your place in front of the camera and use the cable release, remote, or self-timer to take the shot.

Using a mirror. When shooting a reflection, remember to pay attention to your framing and what's visible in the area around you before looking through the viewfinder to focus on your reflection. Once the camera is focused, do not move other than to lower your camera away from your eye to take the shot.

Holding the camera at arm's length. Focus on an object that's approximately an arm's length away from you, then turn the camera around holding it out in front of you— look into the lens or let your gaze fall out of the frame—and shoot.

SOME IDEAS TO TRY

For a fun and impromptu photo shoot with kids, ask them to show you their favorite toy. Kids love to show off their treasured possessions, and while they're explaining how their new car transforms into a robot, you can capture their enthusiasm in a Polaroid. Remember to look for the details—Lego bricks strewn by little feet, a silly hat over messy pigtails, a half-eaten sandwich and a glass of milk.

Lastly, don't be afraid to photograph strangers. It's easiest to start by shooting people from afar, including them as elements of your composition, but when you next come across a person you know would look good in a Polaroid, be brave and ask if you can take their portrait. We find our Polaroid cameras are always conversation starters, so tell your chosen stranger that you're practicing with your new toy and you think they'd look amazing on film. An earnest smile and the humble approach usually do the trick! Make sure you offer to send them a high-resolution scan of the image when you're done—a dreamy Polaroid portrait is guaranteed to make someone's day.

Chapter Three

CAPTURING
THE LIGHT

Light. Creamy, silky light is the element that makes instant film so unique, transforming even the most mundane composition into a magical entity. Likewise, if it's not considered with proper care, it can overwhelm an otherwise perfect photograph. In this chapter we'll walk you through the basics of light from a technical stand-point, and a visual one too. Light is everywhere, and whether it's pouring in through a window or illuminating a landscape, we'll show you how to see the potential of light and harness it within your images. We'll describe some of the key considerations when shooting at different times of day and in varying light conditions, both indoors and outdoors.

Note: Different types of instant film respond to light in different ways, but the basic theories of light usage in photography apply to all types of film. However, if we included specifics for every instant camera ever produced, this chapter would become a book in itself, so to keep it simple, we'll be focusing on the most commonly used models here.

THE TECHNICAL ASPECT

Light is one of the most important elements of a successful photo-graph. Your subject needs to be correctly lit for it to emerge fully developed on instant film, so whether you're using natural or arti-ficial light, there must be enough of it so the camera can see what you're seeing. Most film and digital SLR cameras allow you to manip-ulate your shutter speed and aperture, the two most effective ways to control how much light is entering your camera, and ultimately your shot. Very few instant-film cameras come equipped with shut-ter speed and aperture controls—the most notable are the Polaroid 110B Pathfinder, which can still be found (look for one retrofitted with a peel-apart film back) and the Polaroid Land Model 180. When using these cameras, you'll need an external light meter to measure the light; the shutter speed directly controls how much light is enter-ing the camera (a longer setting equals more light and ultimately a slower shutter), and the aperture controls the depth of field. If you hope to achieve a shallow depth of field (the subject is in sharp focus while the background is blurry), you'll need to use a wider aperture (f-2.8–5.6). We're only touching on this here, as most instant-film cameras do not have these settings. For more detailed information on the basics of shutter speed and apertures, check out the Resources chapter for our favorite books on photography basics. The major-ity of the instant-film cameras produced by Polaroid in the 1970s through the early 1980s, including the SX-70, do not allow the photographer to control the aperture. However, they do feature an exposure dial that can be used to compensate for external lighting conditions—the dial is turned toward the right to darken the image or to the left to lighten the image.

Another way to create light when needed is to use a flash. Most of the early instant SLR models were not equipped with one—though an external unit could be purchased separately—but the modern

Polaroid and Fuji Instax cameras include automatic exposure settings as well as a built-in flash. Many Polaroid shooters avoid using flash because it creates a harsh, unflattering look that's best saved for fun party snaps. If you don't want to shoot with the flash, and the camera does not have an option to turn it off, there are steps you can take to fix this. While some cameras allow you to remove the bulb, attempting this in others can completely disable the camera, so we find that the easiest way to disable the flash is to tape over it with masking tape. Be aware that if the camera was built to sync the flash every time it fires, you'll have to compensate for this with a lot of natural light, very often full sun.

Another consideration is your film's ISO, the rating system that defines the film's sensitivity to light, or "speed." While regular film cameras are used with films of different speeds—the speed/ISO is manually set on the camera once the film has been inserted—with most instant cameras you're limited to the speed specifications of the camera itself. Instant camera ratings ranged from 80 to 3000 ISO—the lower the ISO number the more external light is needed. The SX-70 was built to shoot SX-70 film, a low ISO film discontinued in 2005. Though expired film can still be found in limited supply on the market, your best bet is to use either the new Impossible Project film or expired Polaroid 600 film. Because the camera was created to shoot at a low ISO, it's considered a slower camera than its successor, the 680. As such, it will require more light than the 680 to achieve a properly exposed photograph. If you modify your SX-70 to shoot 600 film (see pages 33–34 for more details), it will respond to the film much like the 680 and 600 model cameras. The 680 and 600 model cameras, introduced by Polaroid in the early 1980s, are overall faster cameras.

There are other tools and tricks you can employ to feed more light into your camera without having to rely on an internal or external flash. Reflectors are large, flexible panels covered in reflective

material that photographers use to bounce light back onto their subject. Available online and in most professional photography stores, they come in a multitude of colors including white, silver, gold, and even black if you need to tone down overly bright natural light. When you're trying to feed as much light onto the film as possible, white is the magic color—white sheets and glossy white boards are less expensive and very effective alternatives.

SHOOTING OUTSIDE

When looking for the light, we automatically head outdoors. But even out in the brightest sunshine there are lighting situations to be aware of when shooting instant film. On a sunny day without cloud cover, most instant films will yield crisp, colorful results, especially in the middle of day when the sun is highest in the sky; however, if

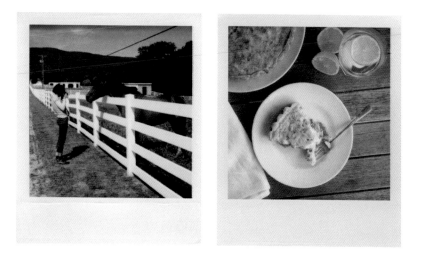

a cloud passes over the sun, it will alter your results dramatically. Below we discuss the most common outdoor lighting conditions, the colors they are likely to produce, and how to compensate if needed.

MIDDAY (FULL SUN AND SHADE)

Shooting at this time of day produces colors that are relatively crisp and bright, but the position of the sun may produce harsh shadows and overexposed areas in your shot. While dramatic shadows on a subject's face can create an interesting effect, for the most part they are not flattering in portraits. Food is another subject that's particularly sensitive to the direction of the sun, so always look for the most evenly cast light you can find when shooting food. Photographs shot at this time of day may have a yellow cast (where the overall image looks very yellow), a frequent problem when shooting expired film. To combat this, position your subject in the shade, making sure the subject still has enough illumination. Lack of light will result in an underexposed image, so if you're using an older camera with exposure controls, try dialing in more light.

SUNRISE AND SUNSET

Regardless of the camera you are using, this is the ideal time of day to shoot outside as the light is rich, soft, and incredibly flattering, especially to skin tones. It's also one of the few times you can shoot into the light without blowing out (overexposing) the entire image. As the sun drops toward the horizon, the light becomes softer and hazy, which explains why photographers call this time of day *the golden hour*. Landscapes take on a magical golden glow as the sun begins to set, and a seascape sunset is a shot every photographer must take at least once in his or her lifetime. To ensure you have enough light on your subject, and to avoid too much backlighting, start shooting at least two hours before the sun actually sets, remembering that the closer the sun gets to the horizon, the darker your subject will appear.

Sunset is also a great time of the day to shoot food; whether it's a single dish or an outdoor table setting, the golden hour lends a lovely warm atmosphere to your shot. Try positioning yourself so the sun streams directly into your lens, producing dazzling sun flare reminiscent of the long summer days of childhood. As the example shows, your results will vary depending on how low the sun is when you shoot and how much light you let in to the camera.

CLOUD COVER

Cloudy, gray days can provide surprisingly beautiful results because the clouds act like a diffuser around the sun, dispersing wonderfully even light across your scene and minimizing the risks of harsh shadows and hot spots. Cloud cover could require the use of a reflector to ensure your subject has enough light, so if you are shooting portraits, angle the reflector to one side of your model to bounce light toward her face, brightening the eyes. Landscapes, street scenes, people, and food all work beautifully in this light. Depending on the type and age of the film you're using, you may find it develops with subtle blue tones.

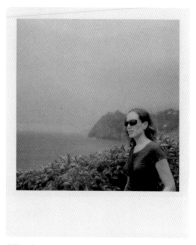

"The sun was just setting as my oldest daughter climbed out of the tent—the resulting flare lends atmospheric charm to the shot." — *Jen (camera: 680SLR)*

"Cloud cover serves well for creating an even, tonal quality to your shot—especially beautiful in portraits." — *Jen (camera: SX-70)*

"The soft, bluish tones married perfectly with the subject of this image. Any stronger light would have been too harsh." — *Amanda (camera: 680SLR)*

"In bright sunlight the limes would have appeared too yellow, but under cloud cover they gained a subtle blue hue in the shadows, which worked so much better." — *Susannah (camera: SX-70)*

SHOOTING INSIDE

Shooting indoors can be a challenge for most instant films, so the more natural light you have coming in from a window, the better your results will be. Ideally, you want to be shooting in a huge, white room with glossy white floors and sunlight streaming through the floor-to-ceiling windows. Alas, perfectly white rooms are a rarity, so attune yourself to how light enters the space you are shooting in, and decide how to best harness it in your image.

NATURAL LIGHT INDOORS

Natural light is the most flattering light to use when shooting instant film indoors, offering much more consistent and even light coverage than that found outside. Strong light will result in harsh shadows just as it does outdoors, so devise ways to filter the direct sun to create a softer light. We use sheer curtains to diffuse the light coming

from a window, and white sheets are very effective if the sun is particularly strong.

Cloud cover also works when you are shooting inside, as you'll find the gentle light coming in has tints of blues and grays that will add a wonderful overall mood to your photograph. Be sure to shoot near the light source to ensure your subject has enough illumination. This may be a good time to experiment with your reflector, homemade or otherwise. Position it opposite your light source to bounce the light off the reflector and back onto your subject, increasing your chances of an evenly lit composition.

You may also need to put your camera on a tripod if your camera compensates for the lack of light with a slower shutter speed to let more light in. If your camera does not have a tripod fixture and the tripod accessory has so far eluded you, try placing your camera on a level surface to help eliminate camera shake—sometimes the simplest solutions are the best. (Note: If using a level surface to steady the camera, you must ensure that the lip of the camera is hanging over the surface—otherwise many of the models do not have the ability to eject the film.)

Additionally, be sure to take into account the type of camera and film you're using when shooting indoors, as many of the integral and peel-apart films are rated 100 ISO, which will require a lot of light for correct exposure. But as always, challenge yourself—sometimes those dark corners of a photograph are where the mystery and beauty lie.

Looking at the examples on the next page shot indoors, can you spot the difference in tones between those that were shot on a sunny day and those shot on a cloudy day? This is the most important lesson regarding light: training your eye. Seasoned instant-film photographers shoot carefully, taking the time to judge when to shoot and when to let the moment pass. Study the light to discover how it shifts during the day and changes with the seasons.

"I played with the shadows and highlights in this image, the sun shining through the window acted as a glorious paintbrush."
— Jen (camera: SX-70)

"I was drawn to the way the light illuminated the tiles on the wall and the contrast between the light and the shadow."
— Susannah (camera: SX-70)

ARTIFICIAL LIGHT INDOORS

As we've already discussed, most instant film responds best to natural light, but obviously there will be occasions when you need to shoot indoors under artificial light. Most integral film was made for natural light, so the tungsten filament found in bulbs will likely result in a strong yellow cast over your photos. You will find this is the case with color peel-apart film as well. When film photography was the norm, photographers used a tungsten filter on their lenses to compensate for the yellow tones in artificial light, so if you're determined to shoot under these conditions, consider buying a filter to hold over your camera's lens—it's not an ideal solution, but it may produce some interesting results.

Depending on the placement of the light source, the strength of the bulb, and the way it's filtered (with or without a shade, for example) you can expect shadows on your subject and potentially uneven illumination. If the position of the light source is out of your

control, be sure to look at your subject from all angles, as moving half a step could make all the difference in eliminating unwanted shadows. Watch the way the light moves across your subject and adjust accordingly. If you are able to control the direction of the light, decide on the effect you are looking for in your shot—do you want the light to illuminate the entire frame or simply be cast across the subject?

The Fuji Instax cameras come with a built-in flash and perform well indoors, though consideration for overexposed images should be taken. Likewise, you are able to shoot indoors with a flash on the SX-70 (separate flashcubes can still be found on the market), or a built-in flash on the 600/680 model cameras and Spectras. The best way to successfully shoot instant film under artificial light is to use black and white film, immediately solving all the color-cast issues. Fuji's FP-3000B black and white film is also very fast, which makes it ideal for low-light situations.

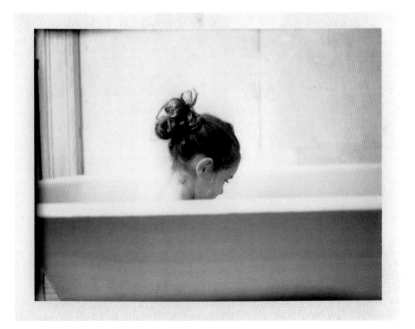

COMPOSITION AND LIGHTING

Aside from your actual light source, the subject and composition must also be taken into consideration when assessing your lighting setup. Some materials absorb the light and others reflect it, so pay attention to whether your subject is pushing too much light back into the camera (which will result in an overexposed image). This tends to happen most often when shooting portraits in natural light and still lifes with high contrasts—a white plate on a dark background, for example. Part of the problem is the camera itself. Due to their venerable old age, most Polaroid cameras don't always produce consistent results, so remember to wait for your first shot to fully develop before shooting again; careful assessment will tell you if you need to adjust the exposure dial or recompose your shot.

"By playing with the exposure dial, I was able to capture the orchids without overexposing them." — Jen (camera: SX-70)

HIGHLIGHTS AND CONTRAST

With this in mind, watch out for the highlights too, especially when shooting in natural light. Highlights are the areas of your shot where the sun is unfiltered and brightest, and will almost always overexpose on the developed film. Perhaps this is the effect you wish to achieve, but if you're looking for even light, watch out for highlights falling across your composition. When dealing with high contrasts in a composition, use even light and keep the camera steady. Higher contrast, like white on black, is tricky and may require less light as the white is pushing additional light into your camera already.

THE ART

Just like the artists of years gone by, you must train yourself to see the light. With practice and a skillful eye, you'll learn to paint with light, creating images that transcend the photographic form and take on the timeless qualities of an oil painting. Photography is an art, and one of the best ways to develop your eye as an artist and understand the light we all crave is to familiarize yourself with the great painters in history. Seek out work by Caravaggio, the Italian painter from the late 16th century, whose dramatic use of lighting has influenced artists for centuries. Likewise, study Dutch painter Johannes Vermeer's use of soft light in his paintings, the way it seemed to cradle his subjects so delicately, particularly in his portraits. Make notes on how they used the light—the way it falls across the subject, the softness of the overall composition—before replicating it in your own work, courageously infusing even more richness and emotion into those little squares of magic.

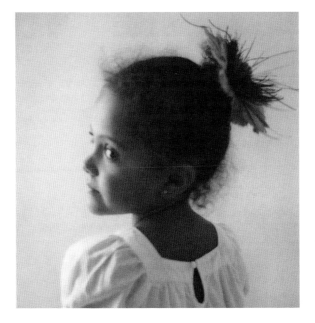

SOME IDEAS

Instant film will always be perfectly imperfect, and that's exactly what there is to love about it. No matter what film you're shooting with, there's always the risk the camera will misfire, or the shot will be overexposed, or the chemicals will be spread unevenly over the print. The flaws and perceived imperfections are what make this art-form unique. And perhaps the greatest wild card of all is the light; the way Polaroid film records daylight simply cannot be replicated with any photo-editing software, making it that much more special. But we ask you to embrace this challenge, as that magic light is likely what led you to pick up this book. We've talked about perfectly lit compositions, and we've also told you to break the rules. Now here are some unusual lighting ideas for you to try.

By shooting toward an open window or door when it is the only light source, you can create a haunting mood that will define the photograph.

Following from the previous idea, try lighting a portrait in a similar way. Illuminate just the person's face and body for stunning and dramatic results. Due to the minimal light used in this setup, it's best to use a tripod for the sharpest possible focus.

If you are able to manually focus your camera, do so on a spot of your subject that is especially well lit; you can create a beautiful vignette (shadowed corners) around the edges of the composition.

Shooting your subject directly in front of the rising or setting sun creates a beautiful golden glow around it.

"The way the light came through this window moved me to pick up my camera—the result is almost painterly." —Jen (camera: SX-70)

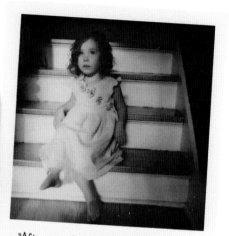

"After days of rain, the sun suddenly streamed into the hallway, dramatically lighting up my daughter's form." —Jen (camera: 680SLR)

"Shooting the butterflies with the flowers behind them highlights their delicacy as the background fades out." —Susannah (camera: SX-70)

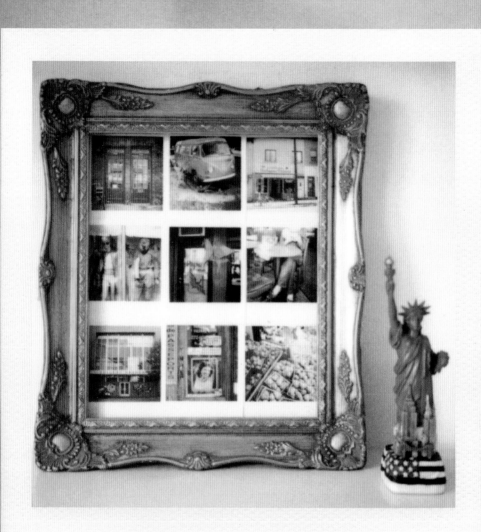

Chapter Four

STORAGE, DISPLAY, AND PROJECTS

So by now you've no doubt fallen in love with your vintage Polaroid camera. You've studied the light, created artful compositions, and recorded memories on those little squares of glossy film, delighting in the *click and whirrr* sound the camera makes every time you press the shutter. And you may think that the fun ends there, or begins again as you pick up your camera—but what will you do with that stack of squares that has begun to grow so quickly? In this chapter we'll share what comes next, from the importance of properly storing your images and ideas on how to display them to projects by some of the most respected and notable Polaroid artists today. Let's have some more fun . . .

STORAGE

Compared to other film mediums, instant photographs are fragile. There are inevitable consequences to the chemicals used in the development process on how the images age. You may have come across Polaroid photographs that you or your parents took in the 1970s and 1980s; most likely they have become yellowed with age. While the chemicals eventually dry, it's their presence in the actual print that can continue to affect its aging process. This is a greater

issue with integral film than with peel-apart, because the paper containing the chemicals is physically peeled away from the photograph with the latter. The chemicals used for this type of film are different, and thus age differently. However, the photographs produced from early peel-apart cameras tend to warp as they age, which is why the safe and effective storage of instant film is essential to its longevity.

Most instant films need to be simply slipped into an album or box for storage. However, some of the early experimental films produced by the Impossible Project did not age well and extra steps should be taken to preserve the developed image. As some of the developed film will continue to shift in color, your best bet for preserving these images is to scan them into your computer. As we've previously mentioned, the Impossible Project films are improving with every new batch that's made, so check out its Web site for the latest updates on the care and usage of its films. You can find this information in the Resources chapter.

The chemical composition of actual Polaroid film—both integral and peel-apart—has been around for decades, so once your

"A Kolo album is a lovely and safe way to store your images; add text and ephemera to create something truly special."
—Jen (camera: 680SLR)

"The Havana box by Kolo fits tons of images and makes it easy to flip through them."
—Jen (camera: 680SLR)

images have developed, the colors should remain true. Careful storage of all of your prints is recommended, keeping them flat and dry and away from extremes in temperature. While most photo albums on the market are designed to accommodate standard-size prints ranging from 4 x 6 inches to 8 x 10 inches, there are a few exceptions available. One of our favorites for both quality of construction and beauty are Kolo albums, in particular, the Riva framed page photo album. Featuring 3.25- x 3.25-inch windows on each page, it's an elegant way to display some of your favorite instant images. Another option is Vue-All Polaroid Preservers—sleeves that are specially designed to fit the integral film. Each sheet holds up to eight Polaroids and they fit into nearly all three-ring binders. Another popular and safe storage option is a photo box. We love the Kolo Havana box because you are able to place the photographs upright in two rows. By creating dividers from your favorite paper or old library cards, you can catalog the images by year, month, or subject.

"Where to put those Polaroids while you are out and about shooting? One favorite is the Moleskine Memo Pocket, an accordion file folder that measures 3.5 x 5.5 inches and is a perfect fit for both integral films and peel-aparts, keeping them safe until you get home." — Jen (camera 680SLR)

SCANNING

In today's world of photo-sharing Web sites and social media, you most likely want to share your instant images with your friends and family the world over. You could slip one into an envelope and send it on its way—and you absolutely should once in a while, a Polaroid is the best mail in the world—but to make it easier to share those images, as well as to create a digital archive, consider scanning your images into your computer. There's a wide range of scanners available on the market at a variety of price points, including everything from dedicated image scanners to printer-scanner-copier combos, so decide what you need and choose accordingly. Using the software that comes with your scanner, try scanning your Polaroids at 300-dpi (dpi stands for dots per inch and refers to the image resolution of your file—the higher the number, the better quality the file when printed) with an image size set to 8 x 8 inches, a great size for making prints as well as digital copies to share online. Once the image is scanned, open the file with any photo-editing software and, if desired, remove any dust marks or scratches that are visible on the scan. If you are shooting with expired film, you may find the colors need to be adjusted—again this is at your discretion and based on how you want your final image to appear. For example, most expired 600 film tends to over-yellow when developing, but this can be adjusted by adding more blue to an image. For detailed instructions on using photo-editing software such as Adobe Photoshop, Lightroom, and Elements, see our Resources chapter for the best books on the market.

ADDITIONAL NOTES

It's important to properly store your film and cameras before you use them. While there are mixed messages in the instant-imaging community about whether to store film in the refrigerator or not, the Polaroid company advised against this, recommending that film be kept at a constant temperature in a cool, dark, dry place. While

keeping the film refrigerated will in fact slow one aspect of the aging process, it does not affect the chemical shifting and will not result in any significant difference when using expired film. You should never store unused Polaroid film in the freezer, as the extreme temperature will affect the battery. If in doubt, check the film's packaging for storage instructions. Instant film, as we've mentioned, is very sensitive to light and temperature changes, so be sure not to keep your film, or a camera loaded with film, anywhere that could experience dramatic temperature changes, such as a car parked outdoors. Even developed film can chemically alter from extreme temperature variations.

DISPLAY

While it is universally understood that as artists we create for ourselves, it is also part of the artistic journey to share our work. Adding pieces of your growing instant-film portfolio to your own

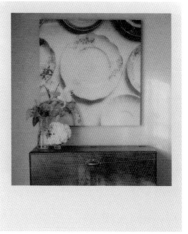

"I converted this Polaroid to black and white with Photoshop and then had it printed as a 40- x 30-inch print—the result is so soft and lovely." — *Jen (camera: 680SLR)*

"I scanned this Polaroid and had it printed on fine art canvas and stretched on pine, resulting in a beautiful canvas wrap—people think it's a painting when they first see it." — *Jen (camera: 680SLR)*

home is not only a way to decorate your space, but it also forces you to observe and critique your own work on a daily basis, gently prodding you to continue your evolution as an artist. We're sharing some of our favorite ways to display Polaroids, but the options are only limited by your imagination.

ON THE WALLS

Polaroids scans are like most digital files and can be printed successfully up to 40 x 40 inches. Be sure to increase your image size when doing the initial scan. You can either retain the square dimensions of the image or crop it in a photo-editing program to fit the frame you have in mind. Polaroid scans also look beautiful printed on canvas and as fine art giclées. (Giclée is a fine art printing process used to create close replicas of original paintings—and now beginning to be used extensively with photography as well.)

Another option is framing the original Polaroid. We have found that most instant images will fit nicely into matteless 4- x 6-inch

"I use Ikea's Ribba frames for my 5-x-5-inch enlargements because they're simple and stylish and let the image sing without interruption."
— *Susannah (camera: SX-70)*

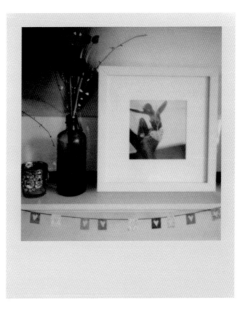

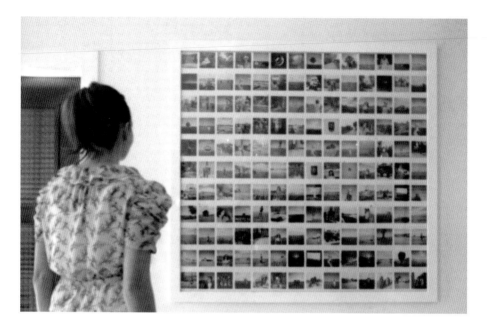

frames. We love Ikea's Ribba frames, as they come in various square and rectangular sizes and are perfect for framing Polaroid prints.

You can also use any size frame and create a collage of Polaroids on a piece of paper that matches the frame size or have Polaroids custom framed. We are smitten with Lori Andrews's Polaroid mosaic. A self-described "insanely happy interior designer and photographer," her work has been a source of inspiration to all of us.

Lori says: "I love shooting instant film. Just a couple of years ago I came across an old Polaroid Sun600 and wonderful photography friends all over the world helped me find film for it—I am very grateful to them. I've brought my Polaroid camera to the tops of mountains, to the fjords of Norway, the wide-open prairies of Saskatchewan, and all stops in between. I wanted to have a permanent way to display and commemorate my love affair with Polaroid so I had my framer display 154 of my favorites under glass. The arrangement is semi-random on purpose.

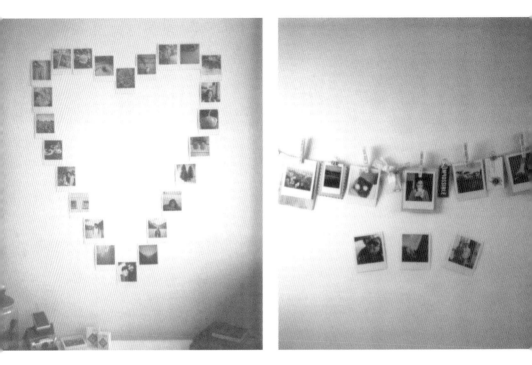

"There is never an unhappy moment when a
Polaroid camera is in your hand."

We also love inspiration wires and wall collages. Add visual
interest to a blank wall by covering it in Polaroids; you can create a
pattern such as a grid or heart or place them haphazardly on the wall.

We have found that both painter's tape and Japanese masking
tape work well for this, as they do not pull the paint from the wall
and are easy to remove from the original Polaroid. Images can also
be clipped to wires with paper clips or clothespins.

OTHER INSPIRED IDEAS

Use fun photo clips
as an informal frame.

Tuck Polaroids into the edges
of existing framed art or mirrors.

Stack images in bowls around the
house, encouraging visitors to browse.

Use an antique frame to enclose
a group of Polaroids together.

MORE INSPIRED IDEAS

Make a tabletop collage by placing Polaroids under glass that rests on top of a table.

Attach instant images of family members on a family tree.

Adhere Polaroids to a memo board with magnets.

Tape ribbon to the backs of Polaroids for use as ornaments on a Christmas tree.

Collage Polaroids in your journals with pretty tape.

GIFTS AND MORE

You've showered your home with Polaroid love, now it's time to share the love. Creating gifts from your instant images is another way that you can share your art with friends and family. Do not be limited by the list of ideas, explore new projects and play, play, play!

Create custom gift tags or labels with your images. After scanning and saving them to your computer, print them on custom templates or cut your own. Paper Source and Avery Labels are good resources. Cards and postcards are wonderful options as well. You

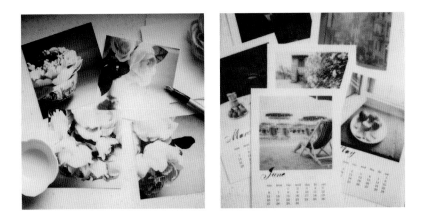

can layer text over your image in a photo-editing software program to create custom messages. Print them yourself or have them professionally printed online by Moo.com or Vistaprint.

Once your image is scanned into your computer, you can use the digital file to create a transfer for custom T-shirts and tote bags by simply printing your photo on transfer paper. Transfer paper is widely available at office supply stores and includes easy-to-follow instructions.

Create custom jewelry with your prints using inexpensive charms with frames. You can insert small prints of Polaroids into the charms and attach them to a necklace or bracelet.

Create beautiful calendars as lovely and personal gifts. Again, once they are scanned into the computer, you can use your instant images in your own layout and simply add the dates. Print one photo for each month or create a wall poster to display several images at once.

PROJECTS

We now invite you to take yet another step in this discovery process. For some, taking the photograph is only the beginning; by manipulating or physically altering your image, you are adding another layer of creativity to your work. The projects on the following pages, generously contributed by artists from the Polaroid community, will walk you through the process for which each photographer is so well known. You will learn how to perform Polaroid transfers with Matt Schwartz of She Hit Pause Studios and Polaroid lifts with Mia Moreno, how to photograph hauntingly beautiful double exposures with Leah Reich and create Polaroid coasters with Parul Arora, and how to transform your instant images into video with Fernanda Montoro.

Polaroid Transfers with Matt Schwartz

www.shehitpausestudios.com

by Matt Schwartz

Matt Schwartz is a Brooklyn-based Polaroid photographer whose studio, She Hit Pause Studios, is well known for beautiful Polaroid transfers. Matt started to play with Polaroid film about seven years ago while assisting photographers as a way to supplement his musical endeavors. "I always loved photography, though never thought of making it a career. The pressure that I put on myself to create music and sign with a record label was not there with photography. I was free and that's why it worked." One day he set up shop in front of the Metropolitan Museum of Art, and the amazing response to his work convinced him that he might be able to create a living as a photographer.

Matt is most well known for his Polaroid transfers, saying that the process "gave my voice as a photographer a microphone." Having started with

3.25-x-4.25-inch 669 film, he eventually moved to 8-x-10-inch large-format film. Matt says, "It adds a whimsical effect to what I am trying to capture. I love the weight that each picture holds. There's no cropping or touching up afterward. Each photograph counts." Of the process he adds, "After I look through the lens, frame up the shot, and press the button, I have little control over where an image peels or how the

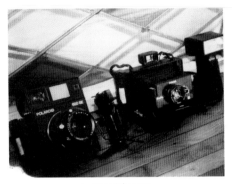

by Matt Schwartz

edges appear. You definitely need to let go as a perfectionist or redefine perfection to mean randomness. Sometimes everything needs to be in alignment from the stars to the secret dance I do while waiting for what I feel is the correct time to pull apart the film (15 to 45 seconds). Other days I am shooting how I want and the Polaroids won't behave." With all experimental processes, the more you play, the more magic you will discover.

MATERIALS

8" x 10" or larger plastic/glass container (water basin)

**Polaroid Land Camera for use with peel-apart film
(see Chapter One for more information on the types of
cameras that take this film)**

669 Polaroid film or Fuji FP-100C instant film

**140-lb. cold-pressed watercolor paper (Arches is my
favorite), cut into 5" x 7" sheets**

**Hard or smooth work surface (preferably something
you use for this purpose alone, as it will get messy)**

4" brayer (rubber roller)

by Matt Schwartz

PROCESS

1. Fill water basin with warm water (not too hot).

2. Load camera with 669 (to develop in the light) or FP-100C (to develop in the dark, see notes below).

3. Find something beautiful or fun and take your picture (leaving the film in camera).

4. Saturate both sides of the watercolor paper with water. Let it float for 10 seconds, then flip it over and soak for another 10 seconds.

5. Carefully place the wet paper on your work surface.

6. If using 669 film, pull the film out of the camera in one fluid motion, wait 15 to 20 seconds, and then slowly pull it apart. Carefully place the negative onto the watercolor paper. Firmly roll over the image with the brayer 8 to 10 times, making sure that every part of the image is rolled. Wait 1 to 2 minutes, and slowly peel the negative from the paper.

7. Let the paper dry.

8. If using FP-100C, pull the film out of the camera in one fluid motion, wait for 15 to 20 seconds, and then slowly pull it apart. Note: The image must be pulled apart in the dark. A closet or bathroom with a little light leaking in (so you can still see what you're doing) will work.

9. Carefully place the negative onto the watercolor paper. Firmly roll over the image with the brayer 8 to 10 times, making sure that every part of the image is rolled. Wait 1 to 2 minutes, and slowly peel the negative from the paper.

10. Let the paper dry.

by Matt Schwartz

Matt notes, "Once you get comfortable with the Polaroid transfer process, you can experiment with shorter or longer times. The times given are a good estimate, though they will change with the brightness or darkness of the object you photographed. In the end, the goal is to allow most of the dye from the Polaroid to remain on the negative, which will be transferred onto the wet paper."

Matt's work is clearly blooming with beauty and passion. "There is no other process that I have come across that 'hugs' the topics I love to shoot, which are currently girls and surfing. All of the people in my photographs are friends or people who have purchased my work. I love the awkwardness/vulnerability of photographing someone not used to being photographed."

by Matt Schwartz

Polaroid Lifts with Mia Moreno

www.thesetenderhooks.blogspot.com

Mia Moreno is a fine arts student from El Paso, Texas. Being able to combine her drawing background with her love of instant film has been a truly romantic and fulfilling experience, as she explains: "I love working with emulsion lifts because I adore the beauty and fragility of the translucent emulsion once it's separated from its original paper backing. My interest in mixed media and appreciation for beautiful fine art papers makes the emulsion lift process the perfect end point for my creative process. Emulsion lifts let me revisit the memory captured in the Polaroid, reminding me of the quiet, surreal aspect of a dream. Once the lift is dry on the paper, it becomes stable and substantial, but still remains ethereal and delicate, which are important qualities in my work."

by Mia Moreno

by Mia Moreno

MATERIALS

669 Polaroid or any Fuji peel-apart film

A pack film

Polaroid camera

Medium-heavy watercolor/printmaking paper, at least 140-lb.-weight is ideal for best results (thin and fragile paper will disintegrate and peel in water)

Electric countertop frying pan

Distilled or purified water

A candy thermometer or a thermometer that is capable of reading 160°F

Three non-metal baking dishes (two a bit larger than the film size and one large enough for the watercolor paper)

Scissors

Contact paper with adhesive

Timer

Tongs

Hard, smooth, flat work surface

Stylus

Tweezers

Brayer (rubber roller)

Drying rack

**Optional manipulation tools that can include:
spray bottle, Q-tips, X-Acto knife, pins, toothpicks,
colored pencils, and watercolor paint**

PROCESS

1. To begin, gather all the materials and prepare the watercolor paper by measuring out from the center, placing light pencil marks to indicate where you want to place your image. Fill the countertop frying pan with enough purified or distilled water to ensure that the entire print will be immersed. Using a candy thermometer, heat the water to 160°F. Additionally, fill three dishes with cool water—two are for working the emulsion from its paper backing, and one is reserved for placing the emulsion on the watercolor paper.

2. You may choose any peel-apart image that has dried for at least 24 hours, prepare it for the lift process by cutting off the white border (which would show up as a pinkish edge all around the final piece). Next, cut a section of contact/shelf paper about ¼ inch larger than the print to provide a temporary border for handling purposes. Peel off the backing and adhere the paper carefully to the print.

by Mia Moreno

3. Once the water reaches 160°F, immerse the print for 3 minutes, starting the timer. Water that is too hot can damage the fragile emulsion, creating cracks and tears. If the water is too cool, the emulsion will have trouble separating from the paper backing. Maintaining the temperature of the water alleviates these potential problems. After 3 minutes, use tongs to lift the photo out of the hot water, and place it in a dish filled with cool water.

by Mia Moreno

opposite by Mia Moreno

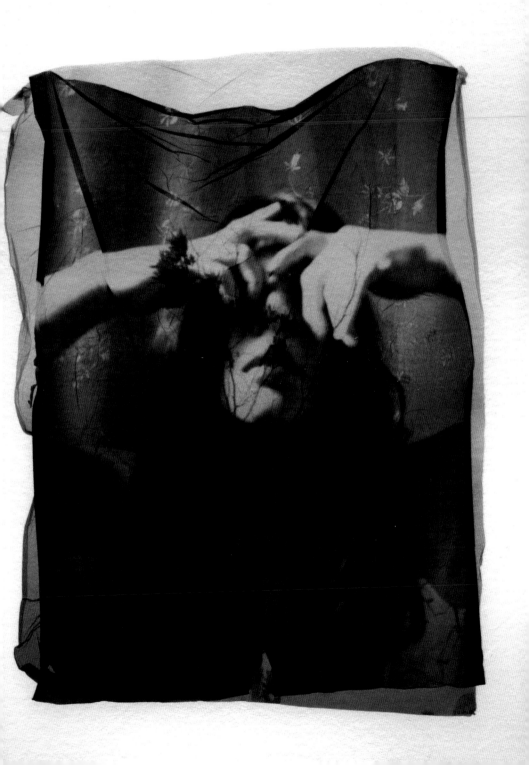

4. Making sure to work underwater, begin at the edge of the print and work your fingers under the emulsion, applying gentle pressure against the paper backing while moving toward the center of the print. A clear gel will come off of the paper backing along with the emulsion, so gently move it away from the floating emulsion (image) with your fingers, transferring the lift (the image) with your hand from one pan to the next. You should now have a transparent image floating in the cool water.

5. Position the watercolor paper underneath the lift in the water, place your thumbs at each upper corner of the emulsion to hold it against the paper, and continue to apply gentle pressure against the paper as you slide it out of the water.

6. Place the paper with the wet lift on a hard, non-porous surface for manipulation—using a stylus and pair of sharp-edged tweezers in addition to your fingers will make it easier. If the emulsion starts to dry out before you are satisfied with the shape, splash clean water from one of the dishes to moisten it. Then, use a wet brayer to remove bubbles and air pockets, rolling it carefully from the center in outward strokes using only the weight of the brayer itself.

7. Working with two lifts for a layered piece is a bit more complicated, but well worth the effort. Mia has worked successfully with two floating images concurrently, as well as with one layer at a time. For the latter, she manipulated the first layer beforehand, and allowed it to dry completely before applying the second layer.

8. Once dry, evaluate the final piece and decide if you want to add any additional visual elements, which could include watercolor paint, colored pencil, or collage ephemera. The emulsion is fairly resilient and substantial at this point, and takes mixed media quite well.

The Double Exposure with Leah Reich

www.ohheygreat.com

Leah Reich is a San Francisco Bay Area–based photographer whose beautiful Polaroid work demonstrates that it's possible to manipulate your film while it's still housed within the body of the camera. Leah's double exposures are well known for their haunting beauty and narrative quality. "The first time I did a double exposure, I was hooked. I wasn't sure what I was doing, or how it would turn out, but I'd seen a few Polaroid double exposures before and had an idea in my head of this image I had to create. I fiddled and fussed, first with a Polaroid 195 and then with a Minolta Instant Pro. A few shots later, there it was: a self-portrait, me sitting in a chair, a ghost slowly fading away." From that point on, with a little imagination and technical know-how, she was making images people swore were either made with magic or in Photoshop.

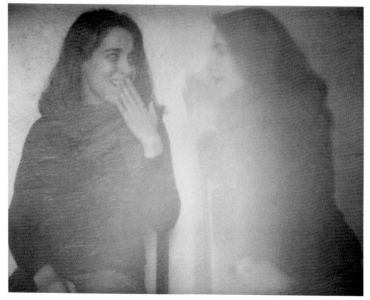

You Can't Keep Anything from Me by Leah Reich

Winter Flowers by Leah Reich

While double exposures with Polaroid look great and at times almost impossible, depending on the type of camera you have, they can be surprisingly easy. They are possible with all forms of Polaroid cameras and film—Land Cameras, Spectra, and SX-70/600. Of this project Leah notes, "I've had the best success using Spectra and so my images have been produced almost exclusively with that film. That's the focus of this project, although I'll briefly review double exposures with peel-apart too." Almost every camera that takes Spectra film is capable of taking a double exposure, with the exception of the 1200FF; you don't even need to have a Spectra camera that has a self-timer to create it. However, if you want to do a self-portrait double exposure, you will need a camera with a self-timer, such as a Spectra System SE. Leah generally uses Spectra film with a Minolta Instant Pro, which has an LED display on the back and includes an option to do multiple exposures.

MATERIALS

Spectra film recommended

Polaroid camera

PROCESS

1. Set the exposure control to "darken" (click it down). You'll be exposing the film to light twice, so this will make both images darker.

2. If it's a night shot, set the flash.

3. Make sure whatever you're photographing is set against a relatively plain background. If it's a darker color background that will help too.

If it's NOT a self-portrait:

4. Hold the shutter release button down to take the first image.

5. DO NOT release the button, not even a little bit.

6. While you're holding the shutter release button down, close the camera.

7. When the camera is closed, release the shutter.

8. Open the camera and take the second shot.

If it IS a self-portrait:

4. Set the self-timer.

5. Take the first shot with the self-timer. Wait until the shutter clicks, about 12 seconds. DO NOT turn off the timer yet (this ejects the photo).

6. Close the camera.

7. Turn off the timer.

8. Open the camera.

9. Take the second exposure normally, either using the self-timer (turning it off after the shot) or by pressing the shutter release button.

It's important to remember that a pack battery is meant to last for the number of shots in the pack, shooting regular images plus possibly flash. Often you can do a full set of double images (and even a triple image), but it's important not to push the battery too much or you'll run out of juice before you finish the pack. Batteries don't last forever, and any regular Spectra film you find is expired, with a battery that's been waiting around to be used. Leah mixes it up, some multiple exposures and some regular shots with each film pack. She notes, "It's pretty disappointing to lose battery power before you finish a pack, especially when you lose it in the middle of taking a great shot!"

Late December, Going Home by Leah Reich

The Long Wait I by Leah Reich

The Long Wait II by Leah Reich

Additional Notes: It helps if whatever you're photographing for a double exposure is set against a plain, darker background. Too many elements can make things look muddy, or they can get lost in the overlapped images. If you're doing two exposures set against the same background, remember to be careful with closing the camera, since you want it to look seamless. In these cases, a tripod can come in handy. Once you get the technical stuff down, you can start to play. That first step, for example: maybe you want your shot to look lighter or more ghostly. Or maybe you're shooting in low light already. Can you play with the exposure setting? The best part of double exposures is thinking about it beyond piling one shot on top of another. What do you want your image to look like? What do you want to be more faded, and what element do you want to be more prominent? If you're shooting the same background twice, with one element removed—such as a person—consider whether you want that element to be more or less pronounced in the final image. Will you include that element in the first exposure or in the second? Including it in the second can make it look fainter, more "ghostly."

As Leah mentioned, it's also possible to take double exposures with Land Cameras and peel-apart film. Take your first shot (and don't pull the image), recock the shutter, and shoot again. You'll want to darken the exposures here too. Most Land Cameras don't have self-timers (only a few models do, such as the 180 and the 195), so these are double exposures you can do with other subject material.

Polaroid Ceramic Coasters using Digital Decal Transfers with Parul Arora

www.justnoey.com

Parul Arora is an illustrator, photographer, and ceramic designer based in London. Using ceramics as a canvas, she combines her illustrations and photography to create playful, quirky tableware that still retains a strong design aesthetic. Parul says, "As a child I was fascinated by the Polaroid camera, and my aunt had one, but I wasn't allowed to use it. I didn't think about it for years but when I started to shoot with film cameras again in 2008, I decided to purchase a used Polaroid Supercolor 635CL from eBay. I think Polaroid cameras have always had that beautiful synergy of analog photography mixed with instant magic." Parul's Polaroid Ceramic Coasters collection came together by accident when she noticed her Polaroids lying on a table and thought how amazing it would be if the pictures were permanent and could be used as coasters.

Parul creates digital ceramic decals, a water-slide transfer printing technique used for printing on ceramic wares that have already been glazed. This technique will work on earthenware, bone china, and porcelain, but the firing temperature will differ. Artwork for the Polaroid images should be scanned at a minimum resolution of 300dpi. To get your transfers made, you will need to send your photo files to a printer specializing in Ceramic and Glass Printing (we've listed a few in the Resources chapter). Note that they usually charge per 8.5 x 11-inch sheet or A4 print.

MATERIALS

Scissors or knife

Digital ceramic transfer

Water bowl

Blank 10-cm x 10-cm porcelain tile glazed on one side

Rubber squeegee

Lint-free paper towel or sponge

PROCESS

1. Cut the Polaroid image transfers neatly to the exact size.

2. Fill your bowl with warm water.

3. Soak the transfer image until it starts to curl and loosen up. Please note that if the transfer is left in the water for too long, it will separate from the paper back and may tear.

by Parul Arora

4. Make sure your tile, glazed-side up, is clean and without any dust or grease.

5. Remove the transfer from the water, and you will notice that the transfer separates from the back paper easily.

6. Take the transfer and slide it onto the tile (glazed side), gently removing the paper back. At this stage, the transfer slides easily and can be adjusted to position it correctly.

7. Use the rubber squeegee and paper towel to take off all excess water. Make sure that there are no water bubbles between the tile and the transfer as this can result in the bubbles bursting during the firing process, resulting in a ruined coaster.

8. Allow the transfer to dry completely for 6 to 8 hours.

9. The transfer and the porcelain tile are now ready to be fired at 820°C, or 1,508°F, in a kiln. If you don't have access to a kiln, simply check the Yellow Pages to find a potter who'll let you use his or her kiln for firing. Additionally, ceramic retailers often have their own kilns and will add your pieces to their firing schedule for a small fee. Once the tile has been fired and cooled down, the Polaroid coaster is ready to be used.

by Parul Arora by Parul Arora

by Parul Arora

A Few Safety Tips

- The transfers are printed using ceramic inks and may contain traces of hazardous elements such as lead and cadmium, so please make sure to ask your local printer for lead-free printing options.
- Make sure that the work area is clean, as any dust particles or grease on the tile can result in defective ware.
- If the transfer is left in the water for too long, it will separate from the backing paper. It is very delicate and can be damaged quite easily.
- The transfer-soaking water should be disposed of properly and changed regularly if creating a batch of coasters.
- Even though it is safe for adults to handle the transfer with their hands, keep the transfers away from young children.

Recording the Development of Integral Film
with Fernanda Montoro
www.fernandamontoro.com

For Fernanda Montoro, it all started five years ago when she came across a self-portrait of a Japanese girl, taken at the Saint-Exupéry Museum, in Hakone. "That photograph hypnotized me; it had colors and textures like I had never seen before. I immediately got in touch with the girl and following her advice, I bought my first Polaroid camera, an SX-70." Since that day, Fernanda, who divides her time between London and her native Uruguay, has never stopped shooting Polaroids, and her work has appeared in editorials all over the world. "I'd found the perfect means to express myself, to share my vision with the world. It is said that sometimes the journey is more important than the destination, and with Polaroid I often feel that is the case." But in time she found that something was missing; after many years of watching her images magically appear in front of her eyes, she decided it was time to capture the film as it developed: "I wanted to see those transient moments as accurately as possible, so I could go back and marvel at them again and again. So, using materials I already had at home, plus a few from the local hardware store, I finally came up with a device I could use to record the magic."

MATERIALS

Tripod

Polaroid camera loaded with integral film

**Video camera or photo camera
(to record the development)**

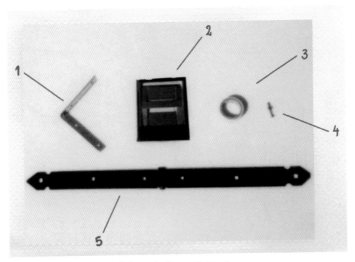

all photos by Fernanda Montoro

MATERIALS FOR MAKING THE DEVICE

1. Corner brace

2. Empty Polaroid film cartridge

3. Double-sided tape

4. Screw and nut

5. Long steel hinge

PROCESS FOR MAKING THE DEVICE

1. First, take an empty Polaroid film cartridge and remove the top part. This will help later when positioning the picture.

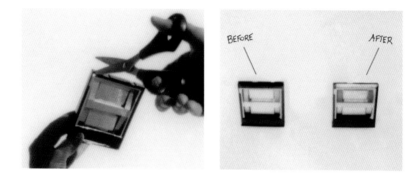

2. Next, screw the corner brace to one end of the hinge. Try to place it as straight as possible, in line with the hinge.

3. Now, using double-sided tape, attach the back of the empty cartridge to the corner brace, making sure it sits centered and straight.

4. Then, mount the other end of the hinge to the tripod. For a good fit, make sure the hinge is thin enough to fit between the camera and the plate.

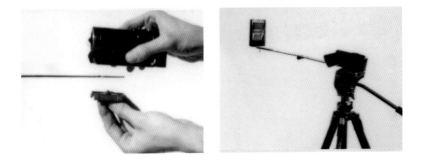

PROCESS

1. Once the instant photo is taken, the developing process starts very quickly and will not allow enough time to adjust the video or photo camera settings. So it's essential that everything is checked and tested before pressing the Polaroid shutter button. A test can be carried out using an old Polaroid photograph as a stand-in. Make sure to check that it's centered horizontally and vertically, that the camera shutter speed and focus are set to manual, and that there are no reflections. Different cameras and light situations will require different settings. Once all is set, you're ready to take the Polaroid photo. Remember to place the exposed shot in the device as quickly and gently as possible, recording for as long as needed; development times vary according to the film used as well as the ambient temperature of the room.

2. To ensure the raw footage is recorded as accurately as possible, keep the video camera in manual mode to maintain uniform light and focus while filming. Be sure to keep the video camera

as still as possible while recording, as even the slightest move-
ment will be noticeable when the clip is played back. When
editing video, try increasing the playback speed by 20 percent to
create a time-lapse video reminiscent of natural history films of
flowers blooming and seasons changing. Adding a layer mask to
the video using a photo-editing program such as Photoshop will
make the cartridge device magically disappear—as the device
remains motionless throughout the clip, a simple mask should
do the job perfectly. To see how Fernanda transforms her footage
into short videos using a layer mask and different speeds, visit
www.fernandamontoro.com/index.php?/personal/video/.

3. Using a stills camera rather than a video camera can produce
images that are beautiful in their own right—look out for sub-
dued colors and tones as your instant image develops. Whether
you use a digital SLR or compact camera, we strongly advise
using a self-timer or remote shutter to prevent unwanted camera
shake. If well recorded, the resulting images could be animated
and turned into stop-motion clips—the possibilities are endless!

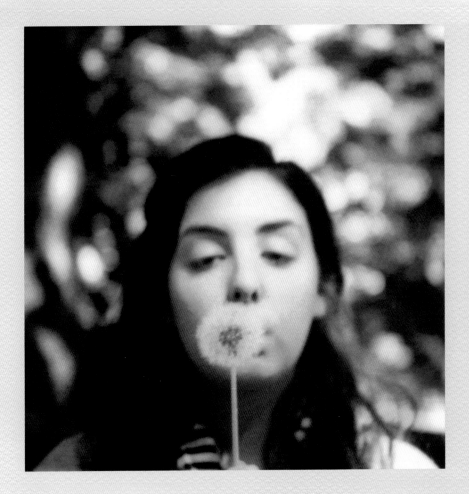

Chapter Five

INSPIRATIONAL
PORTFOLIOS

We've put together five themed portfolios to give you a taste of what's possible with instant film, from the dreamy nostalgia of the sweet and pretty to the gritty elegance of modern-day living, from evocative shots of foreign lands to the beauty and grandeur of the natural world. Not forgetting the joys of a simple meal and food shared with our loved ones. These are a small sampling of the unlimited themes you can capture on Polaroid, so use the portfolios to inspire your own Instant Love explorations.

PRETTY

URBAN

VOYAGE

NATURE

TASTE

RESOURCES

The following lists of resources will give you a place to start when looking for inspiration for your instant images. From contemporary photographers shooting today to books by the masters who went before us, instant photography has a rich history and a very bright future—it starts with you.

WHERE TO FIND US

Jen Altman
www.jeniferaltman.com

Susannah Conway
www.susannahconway.com

Amanda Gilligan
www.amandagilligan.com

VISIT OUR CONTRIBUTORS

Lori Andrews
www.loriandrewsinteriors.com

Parul Arora
www.justnoey.com

Grant Hamilton
www.sxseventy.com

Amy Haney
www.amyhaney.typepad.com

Fernanda Montoro
www.fernandamontoro.com

Mia Moreno
www.thesetenderhooks.blogspot.com

Leah Reich
www.ohheygreat.com

Matt Schwartz
www.shehitpausestudios.com

INSTANT PHOTOGRAPHERS

There are as many Polaroid photographers as there are Polaroid cameras, so we wanted to share a few of our peers, mentors, and inspirations. Dip into the work of these talented photographers to see what's possible with instant film.

Chloe Aftel
www.chloeaftel.com

Lauren Beacham
www.laurenbeacham.com

Anna Beard
www.annabeard.com

Frances Beatty
www.francesbeatty.com

Erin Beedle
www.erinroddy.com

Alicia Bock
www.aliciabock.com

Anne Bowerman
www.flickr.com/photos/anniebee

Tod Brilliant
www.todbrilliant.com

Heather Champ
www.hchamp.com

Rhiannon Connelly
www.rhiannonconnelly.com

Kerry Crawford
www.kerrycrawfordstudio.com

Mat Denney
www.cyanblue.co.uk

Monika Elena
www.flickr.com/photos/26743564@N05

Jennifer Evans
www.jennifer.evans.carbonmade.com

Andrew Faris
www.andrewfaris.com

Parker Fitzgerald
www.parkerfitzgerald.com

Alison Garnett
www.mylalaland.com

Michael Going
www.goinggallery.com

Brigitte Heinsch
www.brigitteheinsch.de

Jessica Hibbard
www.jesshibb.com/

Emily Hunt
www.flickr.com/photos/emilylove

Ieva Jansone
www.jansone-photo.de/projekteievajans.html

Andrea Jenkins
www.hulaseventy.blogspot.com

Whitney Johnson
www.hisampersandhers.com

Lindsay Josal
www.lindsayjosal.com

Morgan Kendall
www.flickr.com/photos/mkendall

Mikael Kennedy
www.mikaelkennedy.com

Cori Kindred
www.corikindred.com

Ann Kathrin Koch
www.annkathrinkoch.com

Nanako Koyama
www.nanakokoyama.com

Darlene J. Kreutzer
www.hippyurbangirl.com

Diana La Counte
www.ourcitylights.org

Jinnie Lee
www.lilacmoonstudio.com

Emilie Le Fellic
www.flickr.com/photos/emilie79

Amanda Mason
www.byamandamason.com

Annie McGarry
www.flickr.com/photos/anniee

Jake Messenger
www.jakemessenger.com

Mathias Meyer
www.holgarific.net

Chinako Miyamoto
www.flickr.com/chinako

Angie Muldowney
www.lemonlight.org

Madelyn Mulvaney
www.persistingstars.com/blog

Irene Nam
www.irenenamphotography.com

Nicolle Null
www.sacredlotus.squarespace.com

Steph Parke
www.stephparke.com

Annette Pehrsson
www.annettepehrsson.se

Kristen Perman
www.violethour.squarespace.com

Erin Power
www.erinpower.com

Robert Reader
www.robertreader.com

Sarah Rubens
www.flickr.com/photos/51674556@N00

Brooke Schmidt
www.alwaystimefortea-brooke.blogspot.com

Jen Shaffer
www.paintedfishstudio.com

Shannon Sims
www.thisismyportfolio.com/archive

Elizabeth Soule
www.esoule.com

Nancy L. Stockdale
www.futurowoman.blogspot.com

Melissa Tochterman
www.hellohiatus.carbonmade.com

Ritchard Ton
www.ritchard.com

Susannah Tucker
www.susannahtucker.com

Dave Tuttle
www.hisampersandhers.com

Jennifer Victoor
www.scissorspaperglue.typepad.com

Charlyn Wee
www.flickr.com/photos/charlynw

Katherine White
www.katwhite.com.au

Azureé Wiitala
www.azureewiitala.com

Patrick Winfield
www.patrickwinfield.com

PROJECTS OF NOTE

Grant Hamilton's documentary, *Full Frame*
Fullfra.me/FULLFRAME/Home.html

Jamie Livingston's Polaroid a day
(1979–1997)
www.photooftheday.hughcrawford.com

Jeremy and Claire Weiss's stunning
portraits
www.day19.com/photos/polaroid-project.html

Mikael Kennedy
www.passporttotrespass.com

New York City Polaroid Project
www.nycpp.com

STORES AND SELLERS

FILM AND CAMERAS

The Impossible Project is manufacturing
new integral film to go in SX-70, 680/690,
600, and Spectra cameras. Film and
cameras can be purchased online, or by
visiting one of its stores worldwide.
www.the-impossible-project.com

Australia
Located in Perth, Western Australia, the
Ruck Rover General Store stocks Impossible
project film and cameras.
www.shop.ruckrover.com.au/cameras-film

Austria
Shop.the-impossible-project.com/stores/vienna
Breite Gasse 11/1/1, 1070 Vienna

Japan
Shop.the-impossible-project.com/stores/tokyo
2F Oak Bld, 1-20-5 Aobadai Meguro, Tokyo
1530042

The Netherlands
Shop.the-impossible-project.com/stores/
enschede
Impossible Factory Outlet, Hoge Bothofstraat
45, 7511ZA Enschede

United Kingdom
Shop.the-impossible-project.com/stores/london
The Photographers' Gallery, 16–18 Ramillies
Street, London W1F 7LW

United States
The U.S. storefront and gallery space for the
Impossible Project
Shop.the-impossible-project.com/stores/ny
425 Broadway, 5th Floor, New York, NY 10013

LandCameras.com converts and restores
pack film Polaroid cameras and offers a
repair and upgrade service for your pack
film camera.
www.landcameras.com

Photojojo sells a wide range of fun photo accessories, including Fuji Instax cameras, Impossible Project film, Polaroid picture frames and holders, and the occasional vintage Polaroid camera.
www.photojojo.com/store

Roger Garrell sells refurbished SX-70 cameras on eBay and offers repairs and restorations services for Polaroid SX-70 and 680/690 cameras.
www.stores.ebay.com/
SX70-cameras-from-Fastcat99

Nate sells reconditioned and modified vintage cameras, including 4- x 5-inch, 600SE, and pack film, plus accessories, new leather skins, and custom conversions.
www.polaroidconversions.com

This Vermont-based shop sells replacement leather covers for the SX-70.
www.cameraleather.com

Freestyle Photographic Supplies sells a wide selection of analog film, cameras and accessories including Holgaroids, Instax cameras, and Fuji pack film.
www.freestylephoto.biz

DISPLAY AND STORAGE

This letterpress studio is known for their gorgeous Polaroid albums.
www.racingsnailpress.com

Store instant prints in 4- x 4½-inch Polaroid Preservers from Archival USA.
www.archivalusa.com

We love book-bound photo albums from Kolo.com, especially the Riva and Havana styles.
Kolo.com

Try Paper Source for blank cards, postcards, and labels for custom stickers.
www.paper-source.com

The Moleskine Memo Pocket organizer has six accordion-file style compartments to store instant prints when shooting outdoors.
www.moleskineus.com
www.moleskine.co.uk

Integral film prints fit perfectly into the 1.6-liter Really Useful boxes.
www.reallyusefulproducts.co.uk
www.reallyusefulproducts.co.uk/usa

CARDS

We love business cards, mini cards, and stickers from Moo.com.
www.moo.com

For inexpensive postcards and business cards try Vistaprint.
www.vistaprint.com
www.vistaprint.co.uk

CERAMIC PRINTING

Parul Arora recommends the following resources for ceramic printing:

In the United Kingdom
www.printdigitalceramics.com

In the United States
www.designpoint.com/home.htm

For more info
www.ceramicdecals.org/Home_Page.html

FRAMES

Instant Frames sells contemporary museum-quality frames designed for Polaroid and Impossible Project instant prints.
www.instantframing.blogspot.com/

Jarrod Renaud makes simple handmade wooden frames for individual Polaroid prints.
www.thelanternroomcollection.com

Ikea's Ribba frames are the perfect size for Polaroid prints and originals.
www.ikea.com

BOOKS

POLAROID BOOKS

100 Polaroids by Patrick Sansone

André Kertész: The Polaroids by André Kertész

The Branding of Polaroid by Paul Giambarba

Found Polaroids by Jason Bitner

Innovation Imagination: 50 Years of Polaroid Photography by Barbara Hitchcock

Instant Light: Tarkovsky Polaroids edited by Giovanni Chiaramonte and Andrey A. Tarkovsky

Julian Schnabel: Polaroids by Petra Giloy-Hirtz

Land's Polaroid: A Company and the Man Who Invented It by Peter C. Wensberg

Like Lipstick Traces: Daily Life Polaroids from Thirteen Graffiti Writers by Jeremie Egry and Aurelien Arbet

Mapplethorpe: Polaroids by Sylvia Wolf

The Polaroid Book: Selections from the Polaroid Collections of Photography by Barbara Hitchcock and Steve Crist

Polaroids: Attila Richard Lukacs and Michael Morris by Attila Lukacs and Michael Morris

Polaroid: Images of America by Alan R. Earls and Nasrin Rohani

Polaroid Transfers: A Complete Visual Guide to Creating Image and Emulsion Transfers by Kathleen Thormod Carr

SX-70 Art by Ralph Gibson

Walker Evans: Polaroids by Walker Evans, and Jeff L. Rosenheim

Xiu Xiu: The Polaroid Project: The Book by David Horvitz

PHOTOGRAPHY BOOKS

Adobe Photoshop CS5 for Photographers: The Ultimate Workshop by Martin Evening and Jeff Schewe

Expressive Photography: The Shutter Sisters' Guide to Shooting from the Heart by Shutter Sisters

The Elements of Photography: Understanding and Creating Sophisticated Images by Angela Faris Belt

Ways of Seeing by John Berger

A World History of Photography by Naomi Rosenblum

USEFUL WEB SITES

A grab bag of useful sites, people, and information.

The Branding of Polaroid
Giam.typepad.com/the_branding_of_polaroid

Instant Options
www.instantoptions.com

The Hacker's Guide to the SX-70
www.chemie.unibas.ch/~holder/SX70.html

Jim's Polaroids
Polaroids.theskeltons.org

The Land List
www.landlist.org

Moominstuff
Moominsean.blogspot.com

Polanoid—an amazing gallery of Polaroid photography from all over the world.
www.polanoid.net

Polaroid Camera Manuals
www.butkus.org/chinon/polaroid_cameras/polaroid_cameras.htm

Polaroid at Camerapedia
www.camerapedia.org/wiki/Polaroid

INDEX

A

Abstraction, 75–76
Accessories, 51–53
Apertures, 96
Arora, Parul, 139–42
Asymmetry, 73

B

Background, 82
Balance, 69
Bokeh, 63
Bosman, André, 14

C

Camera cases, 52
Cameras, instant
Fuji/Fujifilm Instax, 47–49
history of, 13–14
Minolta Instant Pro, 43
Polaroid Automatic Land
Camera Series, 20–25
Polaroid Land Model 95,
15–19
Polaroid Pathfinder, 15–19
Polaroid 600, 36–39
Polaroid SLR 680/
SLR 690, 39–42
Polaroid Spectra, 43–46
Polaroid SX-70, 27–35
Cloud cover, 100, 101, 103
Coasters, 139–42
Color, 73–76

Composition
abstraction, 75–76
asymmetry, 73
balance and unity, 69
color, 73–76
cropping, 68
definition of, 55
depth of field, 62–63
developing skills of, 55–56
framing, 65–66
light and, 77–79, 106
lines and shapes, 70
movement, 68–69
patterns, 71
perspective, 64–65
for portraits, 90–93
positive and negative
space, 66–68
props, 87–89
Rule of Odds, 60–61
Rule of Thirds, 56–59, 69
style, 82–83
subject choice and
storytelling, 81–82,
83–86
symmetry, 72–73
texture, 72
Composition frame cards, 66
Contrast, 106
Cropping, 68

D

Depth of field (DOF), 62–63
Display tips, 115–21
Double exposures, 133–38

E

Emulsion lifts, 127–32

F

Film. *See also individual
cameras*
color and, 73
from the Impossible
Project, 10, 14, 50, 112
integral vs. peel-apart
(pack), 15
ISO, 97
light and, 95, 97
recording development
of integral, 143–47
storing, 114–15
types of, 49–51
Flash, 96–97, 105
Frames, 116–17, 119
Framing, 65–66
Fuji/Fujifilm Instax, 47,
49, 51, 105

G

Gifts, 120–21

H

Hamilton, Grant, 75–76
Highlights, 106
Holgaroid, 52

I

Impossible Project, 10, 14,
50, 112
Indoor lighting situations,
102–5
ISO, 97

K

Kaps, Florian, 14

L

Land, Edwin, 13

Lifts, emulsion, 127–32

Light. *See also individual cameras*

 aperture and, 96

 artificial, 104–5

 composition and, 77–79, 106

 developing awareness of, 78–79, 107

 film and, 95, 97

 flash, 96–97, 105

 importance of, 77–78, 95

 indoor, 102–5

 outdoor, 98–101

 reflected, 79, 97–98

 shutter speed and, 96

 silhouettes and, 79

 unusual ideas for, 108–9

Lines, 70

M

Minolta Instant Pro, 43

Montoro, Fernanda, 143–47

Moreno, Mia, 127–32

Movement, 68–69

N

Negative space, 66–68

O

Outdoor lighting situations, 98–101

P

Patterns, 71

Perspective, 64–65

Polaroid Automatic Land Camera Series, 20–25

Polaroid backs, 52

Polaroid Land Model 95, 13, 15–19

Polaroid Pathfinder, 15–19

Polaroid 600

 film for, 36, 50

 history of, 36

 lighting and, 36, 105

 using, 36–37, 39

Polaroid SLR 680/SLR 690

 accessories for, 51–52, 92

 depth of field with, 62

 film for, 39

 history of, 39

 lighting and, 40, 105

 using, 41–42

Polaroid Spectra

 accessories for, 52

 film for, 44, 51

 history of, 43–44

 lighting and, 44, 105

 using, 44–46

Polaroid SX-70

 accessories for, 51–52, 92

 cases for, 52

 depth of field with, 62–63

 film for, 28, 33–34, 51

 history of, 14, 27–28

 lighting and, 28–29, 105

 One Step, 35

 sonar/autofocus, 35

 using, 29–33

Polaroid transfers, 122–26

Portfolios, inspirational, 149–69

Portraits, 90–93

Positive space, 66–68

Props, 87–89

R

Reflectors, 97–98

Reich, Leah, 133–38

Rule of Odds, 60–61

Rule of Thirds, 56–59, 69

S

Scanning, 114

Schwartz, Matt, 122–26

Self-portraits, 92

Shutter speed, 96

Silhouettes, 79

Storage tips, 111–15

Storytelling, 81–82

Style, 82–83

Subject choice, 81–82, 83–86

Sunrise and sunset, 100, 101

Symmetry, 72–73

T

Texture, 72

U

Unity, 69